beale
STREET

Debbie —
My Best Brother —

Thanks for saving

me... many times.

Jack

beale
STREET

RESURRECTING THE
HOME OF THE BLUES

John A. Elkington

Charleston London

THE
History
PRESS

Published by The History Press
Charleston, SC 29403
www.historypress.net

Cover design by Natasha Momberger

All images are courtesy of the author unless otherwise noted.

First published 2008

Manufactured in the United States

ISBN 978.1.59629.492.9

Library of Congress Cataloging-in-Publication Data

Elkington, John (John A.)
Beale Street : resurrecting the home of the blues / John Elkington.
p. cm.
Includes bibliographical references.
ISBN 978-1-59629-492-9
1. Beale Street (Memphis, Tenn.)--History. 2. Memphis (Tenn.)--History. 3. Memphis
(Tenn.)--Buildings, structures, etc. 4. African Americans--Tennessee--Memphis--
History. 5. City planning--Tennessee--Memphis. 6. Urban renewal--Tennessee--
Memphis. 7. Blues (Music)--Tennessee--Memphis--History and criticism. I. Title.
F444.M575B434 2008
307.3'4160976819--dc22
 2008034255

I dedicate this book to the people who made it a reality: my wife, Valerie; my associate, Dianne Glasper; and my three sons—Fletcher, Griffin and Beau.

"It's the world's longest car, I swear. It reaches from Beale Street to Washington Square. And once you get in it...To go where you're going, you simply get out 'cause you're there."

A Light in the Attic
Shel Silverstein, 1981

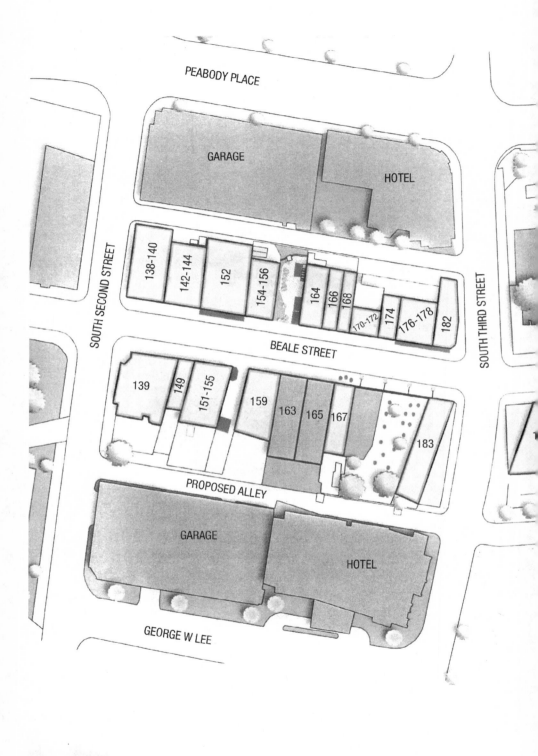

PEABODY PLACE

GARAGE

HOTEL

SOUTH SECOND STREET

SOUTH THIRD STREET

138-140

142-144

152

154-156

164

166

168

170-172

174

176-178

182

BEALE STREET

139

149

151-155

159

163

165

167

183

PROPOSED ALLEY

GARAGE

HOTEL

GEORGE W LEE

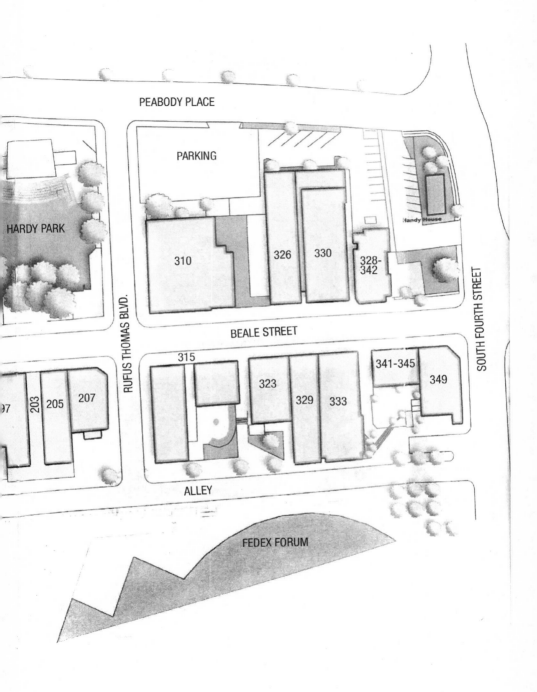

Beale Street Historic District

CONTENTS

PREFACE

The history of Beale Street, and the issues it has faced since its inception, mirror many of the problems that other cities and regions still face today. White flight, urban decay, crime, economic downturns and government indecision are just a few of the issues that have confronted the owners, occupants and residents of Beale Street.

In Memphis, a city famous for distribution, Beale Street was the distribution center from the 1840s through the 1920s. It was from the base of Beale Street and along the river that the cotton industry shipped its product to the world. Memphis's location made it a prime shipping locality in the heart of cotton-growing country.

Beale Street was the center of black migration to Memphis in the 1910s, 1920s and beyond. It was also the site of the last public march of Martin Luther King Jr. It has been visited by some of the greatest civil rights leaders of the era, such as A. Phillip Randolph; Dr. Joseph Lowery; Ralph Abernathy; Andrew Young; Jesse Jackson; Ben Hooks, whose family made a living on Beale Street; and Ida B. Wells, who published her newspaper on Beale Street.

The Beale Street area has been the center of music in the region. Today, the names of nearly one hundred musicians appear in brass

musical notes on Beale Street. It has borne witness to numerous periods of music: the W.C. Handy blues period, the Jug Band period, jazz of the late 1920s and the Sun Record period of the early 1950s. Today, Beale Street still reflects the music of Memphis. It was home to many of the great musicians of the twentieth century, including W.C. Handy and B.B. King, and through its doors passed Albert King, Bobby "Blue" Bland, Howlin' Wolf, Rufus Thomas, Tina Turner, Al Green and the Memphis Jug Band. While this book doesn't concentrate on musicians, it was the musicians who brought people back to the new Beale Street again and again. They included Ruby Wilson, Don McMinn, James Govan, Preston Shannon, Kevin Page and Rudy Williams, to name a few. It was the business home of the great photographer Ernest Withers.

Beale Street was the center of the black community, yet many successful whites, such as Abe Plough and Clarence Saunders, boosted their careers there. It was home to the first black millionaire, Robert Church Sr., Italians, Jews and Irish all made Beale Street their home base. It has been visited by Presidents Ulysses S. Grant, Theodore Roosevelt, Herbert Hoover, Richard Nixon, Bill Clinton and George Bush. In my life, Beale Street has been a great joy. It has also been a very painful experience. Many nights I sat in my den and asked, "Why did I ever get involved in this?"

I hope this book will be a lesson to Memphians that together we can accomplish anything we dream. It is not the critics who count—as Teddy Roosevelt said, it's the people in the arena. Larry Jensen, our former associate, once said, "Say nothing, do nothing, be nothing." I believe the risk both we and our tenants took was the reason the development was successful.

I couldn't have written this book without the help of Dianne Glasper, my assistant and friend, who typed every word in this book more than once. She also gave me comments and suggestions.

I thank my lifetime friends on Beale Street—Al James, Cato Walker, Maxie Hardy, Preston Lamm, Fran Scott, Silky and Jo Ellen Sullivan, James Clark, Mike Glenn, Bud Chittom, Sandy Robertson, Jimmy Silvio and Tommy Peters—for their help. I also want to thank Kevin Kane, whose outstanding leadership made

the Memphis and Shelby County Convention & Visitors Bureau an instrumental partner in the property and in the development of the tourism industry. He further showed his support by investing in Beale Street businesses even when it wasn't a sure thing.

There are numerous texts about Beale Street, but none is better than Joe Doyle's "The Politics of Redevelopment: How Race Impacted the Rebirth of Beale Street 1968–1971." It was a well-thought-out thesis that was helpful in recalling the struggles of the Beale Street Historic Foundation. But more importantly, it pointed out the animosity that the Memphis Housing Authority invoked with its 1968 Urban Renewal Plan, which was implemented four months after the assassination of Dr. Martin Luther King Jr. The plan halted business on Beale Street and moved over three hundred families from south and east of Beale, creating a wasteland and tearing the fiber out of the Beale Street area. This sparked a fifteen-year struggle to "bring Beale Street back"—a struggle that was ugly, misguided and full of incompetent moves by the Memphis Housing Authority, the City of Memphis, developers and quasi public and nonprofit groups. It included all of the elements that could be found in an American city during the 1960s and 1970s—race, mistrust and conflicting views on how to renew a declining area.

Into that cauldron, in 1981, we came to try to develop Beale Street into a viable commercial entity. Not the romantic version of what it was in the 1920s, 1930s and 1940s, not the grotesque version the Memphis Housing Authority and private developers proposed in the 1970s, but a version in which blacks and whites could socialize in a new Memphis. In retrospect, we should have failed as the City of Memphis and other critics had predicted. The odds were certainly against what we wanted to do. We succeeded because of our will and the will of our tenants. There is one prevailing theme in this story—government doesn't solve problems. It is government working with private developers that make things work.

In the eyes of purists, early on, the new Beale Street didn't resemble the Beale Street of the 1920s, 1930s and 1940s. They complained about that. They also complained that it didn't

represent the same social meaning it once had in its vital role in sustaining African American culture. They missed the point. The Beale Street we set out to create was to celebrate diversity, which it does; to promote and grow the music industry in Memphis, which it does; and to create a place where people could enjoy what makes Memphis special.

Jeff Sanford, chairman of the Center City Commission, once said to me, when I asked him whether I should redevelop Beale Street, "John, you're nuts." Well maybe I was—to risk everything, including twenty-five years of my life. But, after all, that is how things get done.

Finally, if Rickey Peete hadn't been involved, Beale Street wouldn't have reached maturity. His demise broke my heart and the hearts of many others on Beale Street.

And to my sons, Fletcher, Griffin and Beau, never be afraid to raise the bar until you miss. It is better to fail then never to try at all.

BEALE STREET'S HISTORY

No one knows the exact year Beale Street began, and no one is absolutely sure how the street got its name. There are real estate records that date back to 1841, when Beale Street was a principal avenue in the separate community of South Memphis. Legend has it that the developer of South Memphis, Robertson Topp, an entrepreneur and an attorney with the Memphis and Charleston Railroad, named the street after Thomas Beale, a hero of the War of 1812 who, during the Battle of New Orleans, organized a band of sharpshooters to beat back the British.[1] Actually, it is difficult to determine if this is correct since many of the early maps of the area spell the name "Beal" instead of "Beale."[2]

Regardless, Beale Street was originally part of South Memphis, which was a separate community from Memphis. Although Memphis had been incorporated as a city in 1826, it didn't consolidate with South Memphis until 1849, when the citizens voted on a referendum to consolidate.[3] On January 1, 1850, the two towns merged, and Beale Street became a street in Memphis. Beale Street ran one mile to the east from the Mississippi River.

In the late 1840s and 1850s, the western portion of Beale Street (the portion closest to the Mississippi River), was the

center of commerce for the area. During these years, the Memphis economy revolved around cotton exportation. By the 1850s, Memphis was exporting 400,000 bales per year.[4] The cotton was brought to Memphis from the cotton-growing region, and as a result, Memphis became the center of distribution for the cotton industry. Beale Street merchants catered to the needs of the river men, dockworkers and shippers. Loading and unloading the steamships required extensive labor and were both strenuous tasks.

The eastern portion of Beale Street, from Wellington (now Danny Thomas) to Manassas, was an affluent area occupied primarily by white families. Fine houses dotted this portion of Beale Street. Today, the Hunt-Phelan House at 533 Beale Street remains intact and symbolizes the grandeur of the residential portion of Beale Street.

In the 1830s and 1840s, immigrants, who had come to the region seeking their fortunes, settled into the business section of Beale Street. The early mix of owners flourished in the area, and there was significant growth during this period. There were no people of color recorded in the 1849 city directory, and only three were listed in the 1855 directory, including Joseph Clouston, a freedman, and two other individuals who may also have been freedmen. All three were barbers.[5]

The Civil War would affect Memphis as it did other Southern cities, with a few exceptions. First, Memphis suffered little physical damage from its capture and occupation. The battle to secure Memphis (a ninety-minute battle fought entirely on the river) was over quickly, primarily because of the overwhelming superiority of the Union army. It was the first major Southern city to fall to the Union. Second, Memphis quickly became home to slaves who left the Mississippi Delta. Blacks migrated to the safety of Memphis.[6]

Memphis fell to the North on June 6, 1862. After the fall, the city became the staging point for the military campaign to secure the state of Mississippi, the Mississippi River and its Natchez and Vicksburg ports for the North. Ulysses S. Grant made his

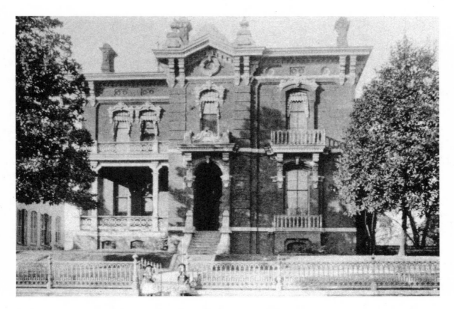

A house on Beale Street. *Photo courtesy of Robert T. Jones Jr.*

headquarters at the Hunt-Phelan House on Beale Street. It is here that he planned the siege of Natchez and Vicksburg. During that time, many of the newly freed slaves gathered around Grant's headquarters for protection. This event marked the beginning of the African American community's relationship with Beale Street.

From 1862 to 1867, Civil War displacements and Union army occupation produced a phenomenal growth in the African-American population of the city; by 1865 the number of Blacks had tripled, and they accounted for 16,509 of Memphis's 27,703 inhabitants. Almost all these rural immigrants lived in contraband camps, including Camps Dixie and Shiloh ("New Africa"), south of Beale Street near Fort Pickering and President's Island. Some of the migrants would make their fortunes in Memphis, providing goods and services to the large, postwar Freedmen population.[7]

Safety was always a concern for many of the newly freed slaves. The cultural differences between the Irish, who composed much of the Memphis Police Department, and blacks were significant. The excruciating tension between the two groups boiled over in 1866. A bloody race riot occurred, sparked by the collision of two carts at the intersection of Beale and Main. An argument between the two young drivers, one black and the other Irish, ended with the death of the Irish boy. Black Union troops prevented the police, who were predominately Irish, from making an arrest. Led by the police, hundreds of whites descended on Beale Street, where they burned and looted buildings and killed scores of residents. This led to one of the worst race riots in the history of America: the "Memphis Massacre."[8] The Memphis Massacre resulted in the deaths of two whites and forty-four blacks. In addition, the rioters burned down ninety-one black houses, four black churches and twelve black schools.[9]

In spite of this event and other indignities endured by African Americans, Beale Street had fully become the cultural center and the local headquarters for commerce, politics and religion for blacks. From 1866 to 1874, twenty black-owned businesses and a Freedman's Bank existed in the area. Blacks controlled the barbering and local taxi (hack) and freight businesses until the streetcar system and immigrant competition put them out of business in the 1880s.[10] Other immigrants also came to the area. Germans and Italians joined the African Americans and Irish on Beale Street. Memphis continued to be the center of distribution for the cotton industry as vast shipments of cotton moved into the city for shipment directly to Britain. Under this layer of frantic commerce, a major problem festered.[11]

Memphis suffered from terrible sanitation problems that, during the long, hot summer, would make the town intolerable. The lack of proper sanitation caused three different epidemics of cholera and yellow fever in 1867, 1872 and 1878. These epidemics killed thousands of people and caused thousands more, who had no idea what caused these epidemics, to abandon the city for safety. The single most significant event in the history of the city of Memphis

was the yellow fever epidemic of 1878. The situation was so bad that Memphis declared bankruptcy and the state revoked its charter. Yellow fever was far deadlier to whites than blacks. The black population seemed to have a greater immunity to the disease, and most of the blacks affected recovered. By the end of the 1878 epidemic, the population had been reduced from over fifty thousand to fewer than fifteen thousand, and blacks outnumbered whites by a ratio of more than six to one. They remained in the area and helped rebuild after the epidemic was over. Robert Church Sr., who is credited with being the first black millionaire in the South, was chiefly responsible for helping blacks and whites rebuild the area after the 1878 epidemic.[12]

Church, a freedman who migrated into the city during the Civil War, helped transform the eastern portion of Beale Street from an upper-middle-class neighborhood for whites to a commercial street for African Americans. In 1880, white families started their flight from Beale Street. In 1899, Church responded to the city's segregation practices by purchasing six acres of land to build Church Park and a two-story auditorium that seated two thousand people and included a parlor, meeting rooms and a refreshment stand.

Adjacent to the Church Park Auditorium stood the Beale Street Baptist Church, a beacon on Beale Street. In the early 1880s, the congregation's membership stood at over twenty-five hundred members. It was a powerful and influential church. In April 1880, Ulysses S. Grant visited the church. Its pastor, Taylor Nightingale, ran for the City Board of Education in 1886. The famous civil rights editor Ida B. Wells, whose newspaper was located on Beale Street, was also a member of the church. In the early twentieth century, Pastor George A. Long led opposition against Mayor Edward H. Crump, the democratic leader of the corrupt political machine that ruled Memphis for decades. Crump and the local police were infuriated when Pastor Long allowed the radical Negro union leader and civil rights activist A. Phillip Randolph to hold a rally in the church. Long replied to their threats by saying, "Christ, not Crump, is my Boss."[13]

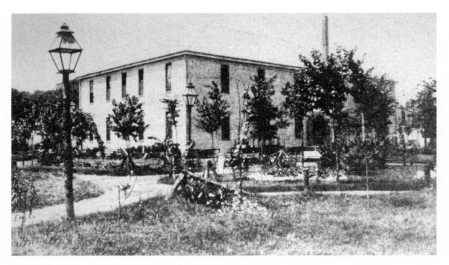

Church Park Auditorium. *Photo courtesy of Robert T. Jones Jr.*

For almost fifty years, Beale Street was officially Beale Avenue. In 1908, the city gave a nod to the progressive-era orderliness by declaring that all north–south thoroughfares were streets, while east–west connectors became officially known as avenues. In 1955, comedian Danny Thomas preserved the traditional name when he asked the city commission to change it back, officially, to Beale Street.

Also in 1908, W.C. Handy, an accomplished band leader and songwriter, gravitated from Clarksdale, Mississippi, to Memphis and Beale Street. Beale Street was a lively strip of stores and saloons and was the heart of the growing African American community. Music was already a fixture on the street. Handy brought with him the blues, a new style of music "he experience in the Delta." In 1912, he published the "Memphis Blues." He arguably became one of the first musicians to publish a song featuring characteristic "Blues Notes" that also contained the word "Blues" in its title. The composition was originally titled "Mr. Crump, a campaign tune commissioned by mayoral candidate E.H. 'Boss' Crump." The song was not especially flattering to the candidate, but it was effective.

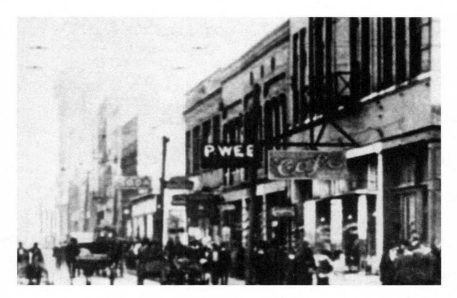

A view from Beale Street around the turn of the century. *Photo courtesy of Robert T. Jones Jr.*

Mr. Crump doan allow no easy riders here.
We doan care what Mr. Crump don't allow;
we gonna barrel-house anyhow.
Mr. Crump can go and catch some air. [14]

But Crump didn't seem to mind. He liked the tune, and so did the black and white voters who came out to his rallies to hear Handy's band play it. Crump was elected, and Handy's tune became a hit. Labeled the "Father of the Blues," Handy quickly followed up his success with such classic compositions as "St. Louis Blues" and "Beale Street Blues" before moving to New York to set up his own music publishing business.

Over the next few decades, bluesmen poured into Memphis from the Mississippi Delta. This mass migration made Memphis, and more specifically Beale Street, a musical boomtown and a key place for musicians to cut their teeth.

The Mississippi River flood of 1927 decimated Mississippi, parts of Arkansas and Louisiana, causing a tremendous migration

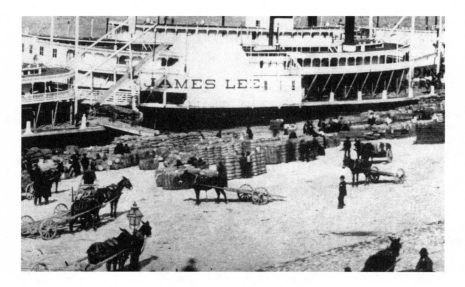

The Mississippi River made Memphis a natural shipping hub. Here, loads of cotton are loaded onto the waiting vessel. *Photo courtesy of Robert T. Jones Jr.*

of blacks from the Delta to Chicago and other Northern cities. The "Great Migration," which had begun in 1917, had sent more than half a million African Americans northward and would propel a million more to follow before the end of the 1920s.[15] The main route north was the Illinois Central Railroad, which charged $11.13 for a ticket from Memphis to Chicago. The main point of exodus was the Central Station—six blocks from Beale Street.[16]

In the 1920s, Beale Street patrons favored the blues sounds of "jug bands," such as the Memphis Jug Band and Gus Cannon's Jug Stompers. These groups played blues, but their style owed as much to the music of minstrel shows as it did to Delta Blues.

Later, Muddy Waters, Albert King, Bobby "Blue" Bland, Memphis Minnie, Memphis Slim, Furry Lewis, Howlin' Wolf, Rufus Thomas and B.B. King (who received his name "Beale Street Blues Boy" on his fifteen-minute show on WDIA in the late 1940s) all found on Beale Street an education in the blues and a chance to project the music of the Delta to a wider audience.

Beale Street, circa World War I. *Photo courtesy of Robert T. Jones Jr.*

A shipment of cotton makes its way down Beale Street, en route to the docks.

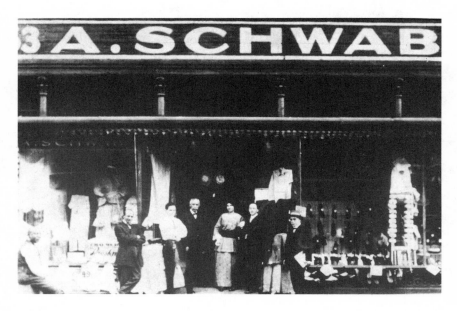

Established in 1876 by Abraham Joseph Schwab, A. Schwab's dry goods store is the only remaining original business on Beale Street. *Both photos courtesy of Robert T. Jones Jr.*

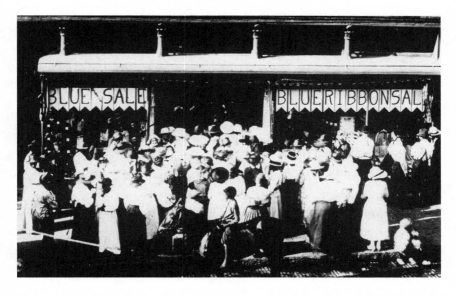

A crowd gathers for a "blue ribbon sale" at A. Schwab's. *Photo courtesy of Robert T. Jones Jr.*

Toward the end of the 1940s, a young radio station employee, Sam Phillips, resolved to record some of the blues he was hearing in Memphis. Phillips opened the Memphis Recording Service and forged relationships with labels RPM and Chess. He recorded B.B. King, Howlin' Wolf, Ike Turner, Rufus Thomas and others before creating his own label, Sun, in 1951. Sun was located at 706 Union Avenue, one block from the eastern portion of Beale Street.[17]

For Sun, Phillips continued to record blues artists, but he began looking for a "White man who could sing with the spontaneity of Black artists." The cold fact was that, in 1950s America, black music sold only to black audiences. It seemed that the Blues had to be filtered through white lungs before it could reach a white audience. Sun would record a raft of white artists, some of whom mixed blues, country and gospel to create something new—rock n' roll.

THE DECLINE OF BEALE STREET

The decline of Beale Street began seriously during the late 1950s. Beale Street fell victim to difficult economic conditions, racial tensions in the community and suburbanization, all of which contributed to the physical and economic decline in the area.[18]

In the late 1960s, the city, in an attempt to remove deteriorating buildings in the area of Beale Street, implemented the Department of Housing and Urban Development's Urban Renewal Program.[19] The Urban Renewal Program removed many of the deteriorated structures, leaving vacant parcels and the structures that now exist. In June 1966, Beale Street was designated a Registered Historic Landmark by the Department of the Interior. At that point, the City of Memphis owned all of the property from Second to Fourth Street, with the exception of 165 Beale Street. Development and the restoration of the district would be hampered by a lack of funding, a lack of organizational leadership and the economic risk associated with development under those circumstances. The plain fact was that developers were turning away from downtown and toward other places in the community.[20]

The final blow to Beale Street occurred when, during the Sanitation Strike of 1968, a march led by Martin Luther King Jr. down Beale Street ended in a riot. King was forced to leave the street for his safety. That event was the symbolic end to Beale Street and the start of its excruciating rebirth.

The tragic final decline of Beale Street began in August 1968, when the Memphis Housing Authority approved an Urban Renewal Plan that not only removed businesses from Beale Street, but also three hundred families who lived south and east of the Beale Street area. The bitterness that plan caused created much of the animosity in the black community that continued even when we became involved in 1981.

Throughout the 1970s and 1980s, blacks and whites had only begun to socialize and work together on the problems in our city. There were moments when the city came together, like during the

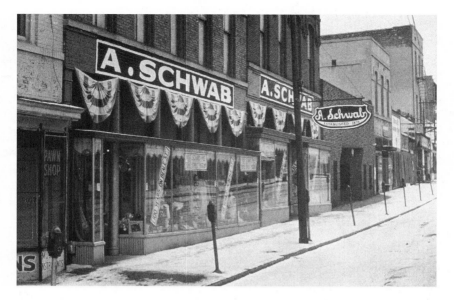

A. Schwab's storefront, circa 1980.

A parade makes its way down Beale Street, circa 1950s.

1973 Memphis State University basketball team's trip to the Final Four, where two black Memphians, Ron Robinson and Larry Finch, along with their teammates and coach, Gene Bartow, went to the final game against UCLA. However, the euphoria was interrupted when they returned to Memphis, where a predominately young and black crowd booed Mayor Chandler during a public ceremony honoring the team.

However, there were countless other incidents that created mistrust among the people in Memphis. Strikes at Cleo Wrap and the Memphis Furniture Company contributed. School-ordered busing divided the community. The police department's treatment of black citizens and various mayoral races created division in the city. The political talk was always about getting a certain percentage of the black or white votes. The city had lost focus on where it wanted to go and how it planned to get there.

HOW WE GOT INVOLVED

MEMPHIS IN THE 1980S AND THE JOBS CONFERENCE

The successful redevelopment of Beale Street began in the lobby of the Peabody Hotel. The citizens of Memphis were there for a Memphis Jobs Conference. The Jobs Conference was the brainchild of the newly elected governor of Tennessee, Lamar Alexander, and was designed to help identify Memphis's economic future and to develop a community plan to move the city forward. Its purpose was to hear Memphian's ideas and thoughts about their city, develop specific goals for the city and outline a plan to implement these goals.

I was invited to be a panelist at the second annual meeting because my company, Elkington & Keltner, had gained a lot of exposure from its developments and my civic involvement in Memphis. Elkington & Keltner was a high-profile development company that attracted young people who previously had limited opportunities to get into the real estate development business in Memphis. Larry Jensen, Cary Whitehead, Mike Ritz, Preston Lamm, Cynthia Ham and Larry Wade were all attracted to Elkington & Keltner and have, through the years, made great contributions to Memphis.

In preparation for being on the panel, I went to Baltimore to see the renaissance that city had begun. The redevelopment of the inner harbor into a festival marketplace had caught the imagination of the real estate development community throughout the country. This concept would form the basis of urban redevelopment in cities across the nation. In the 1980s, developer Jim Rouse had created Faneuil Hall Marketplace in Boston, Harbor Place and Norfolk's Waterside. He had a clear understanding of what it took to revitalize decaying urban areas. In August 1981, *Time* magazine featured Rouse on its cover, quoting generously from the developer's urban philosophy and outlining his long history of city shaping, from 1950s urban renewals to the "fun" of the festival marketplace. Rouse was the developer of Columbia, Maryland, a model new city.[21] He had, in fact, tried to develop "Shelby Farms" in a joint venture with Boyle in the early 1970s, but the project was turned down by the county commission. On the night of the Jobs Conference, Rouse asked me, "Whatever happened to that property?" I said nothing. He commentated that we were lucky it hadn't gone through because it would have hit the recession of the mid-1970s. He knew Memphis, and he knew that developers were abandoning downtown and moving their developments to the east.

The revamping of downtown would be one of the critical issues being addressed at the Jobs Conference. In the 1970s and early 1980s, the deterioration of downtown Memphis had begun at an accelerated rate. The downtown department stores—Lowenstein's, Gerber and, finally, Goldsmith's—either left or went out of business. Downtown was no longer the center of office development in Memphis. Office developer Boyle Investment moved its office from Third and Monroe to East Memphis. Texas developer Trammell Crow formed a partnership with Tommy Farnsworth and concentrated its efforts in East Memphis. Clark & Clark developed Clark Tower, which became the tallest office building in the city, on Poplar Avenue in East Memphis. Suddenly, East Memphis became the center of commerce. Even the city planning department was assisting this exodus with its "multi-center concept plan," which

called for office concentration in East Memphis and the airport area with the same emphasis as downtown.

This movement east was also stimulated by the fact that the city of Memphis could not grow west because of the Mississippi River, and people were pushed farther away from downtown. The failure of the I-40 connection through Overton Park further contributed to the isolation of downtown. Court-ordered busing accelerated the movement of builders to Germantown and Bartlett because people didn't want to put their children in city schools. For the next twenty years, the city of Memphis had to be satisfied with infill developments as its only housing growth.

In 1974, the Peabody Hotel closed and was sold on the courthouse steps. Many of the fundamental businesses in Memphis (cotton, hardwood and river transportation industries) were going through restructuring. The International Harvester and Firestone plants closed. RCA came and went in three years. Other employers, like Holiday Inn and Cook Industries, which had been a steady influence in the 1960s and '70s, faced new economic challenges. The cities in the region against which we actively competed in the 1960s and '70s were moving ahead of Memphis. Suddenly, people were asking why we couldn't be another Atlanta or Dallas. Later, in the 1980s, people were asking the same question about Nashville, Charlotte and Jacksonville. The city began losing the "can-do" attitude that had been prevalent in the early 1960s.

The Jobs Conference organizing group had created a development panel to discuss how downtown could move ahead. The panel included both Memphians and experts from outside Memphis. My panel included Jim Rouse, the Baltimore developer; Mike Rose, the president of Holiday Inn; Donald Schaffer, the mayor of Baltimore; and me. The moderator was Neil Pierce, the syndicated columnist for the *Washington Post*. Earlier that day, I had been asked by the organizers to meet Rouse, Schaffer and Walter Sodheim (who was head of the Greater Baltimore Committee, a quasi government community redevelopment group) at HI Air, a private terminal, take them to the town hall meeting and then return them after it was over. Rouse was one of the developers I

most admired, and Schaffer was a dynamic political leader who later would become governor of Maryland.

On the way to the Peabody, we talked about what was going on in Memphis. Schaffer commented on how clean Memphis was, and Rouse asked, "John, could you give us a quick tour of what's happening downtown today?" I showed them Lyman Aldrich's River and Front Row Apartments, Henry Turley's Shrine Building and a condominium developed by Carol Coletta, Norm Brewer and our Lenox School architect, Jack Tucker. I also showed them Mud Island from a distance and Beale Street under construction. In addition, I found myself saying often: "This is going to be an apartment complex" and "They are tearing down this building to do an office." We went around the same development block at least twice.

I would give that tour many times over the next twenty years to lenders, restaurateurs, developers and public officials from other cities, but I was never as nervous showing off Memphis as I was that night. I wanted them to see the possibilities and like Memphis.

When we finally got to the Peabody, my co-panelists went up to their rooms to get ready for the night. I went to the lobby. As I walked in, I saw a friend of mine, Sonia Walker, who worked at WHBQ-TV as a community relations person, sitting with Reverend James E. Smith, the head of AFSCME (American Federation of State, County and Municipal Employees). They asked me to join them. The room was abuzz with conversations about how attendees could make Memphis a more dynamic place to live. Reverend Smith was holding court, detailing his thoughts about what the city needed. I didn't know him, but after spending the evening with him, I was enthralled. He was a dynamic personality who had a wonderful laugh. He also had a lazy eye, so you never knew whether he was looking at you. He had just taken over as chairman of the Beale Street Development Corporation (BSDC), a maligned group that was the third to attempt to move Beale Street forward. The previous two groups had tried and failed to redevelop Beale Street. Smith's organization had no money, except for a marketing commitment of $25,000 from Miller Brewing, no real estate development or leasing

Decades of neglect left Beale Street a run-down skeleton of its once vibrant existence.

experience and no construction or management background. It had two full-time employees: Billy Heard, who had a marketing background and was the executive director, and Al James, who was in charge of the site. Al would soon leave BSDC and become a central figure in our redevelopment of Beale Street. Out of the night's long conversation, the group at Reverend Smith's table came to two conclusions: 1) Reverend Smith wanted to complete Beale Street, and 2) he needed a developer.

Reverend Smith was impressed by the Belz family and their success at the Peabody Hotel. The Peabody Hotel had just been renovated and was the cornerstone of a new downtown Memphis. The question was whether the Belzes wanted to get involved in such a controversial development. They didn't. Later, Gary Belz told me, "You know we could have had Beale Street if we wanted it." We knew that we were the second choice, but sometimes it is better to be the bridesmaid rather than the bride.

I explained to Reverend Smith that my interest in Beale Street was not as a developer, but as a Memphian who was interested

in seeing the street redeveloped. I told him I had served on the nonprofit Beale Street Historic Foundation, which was one of the early groups that made an attempt to redevelop the street. The foundation had brought together an incredible group of twenty-two people (thirteen blacks and nine whites), including Ron Terry, president of First Tennessee Bank, to move the property forward. Unfortunately, it never happened. I discussed with Reverend Smith why it failed. I told him that a new Beale Street would be good for the city and that it could become a key ingredient in developing a tourism industry for Memphis. Memphis desperately needed a job and tourist industry that could create easy entry jobs for a large portion of its population that lacked the skills or the education required for higher technical jobs.

Reverend Smith was also aware that I was talking to Joe Sabatini about working for Elkington & Keltner. Joe was the personnel director for the City of Memphis and had worked closely with Reverend Smith during labor negotiations with the City of Memphis. I had first met Joe when I was a park commissioner for the Memphis Park Commission. I was impressed by his professionalism, intelligence and good-guy nature and thought he could be helpful in shaping our company's future.

Reverend Smith knew Joe was leaving the City of Memphis and looking for a new job. That evening, he pressed me to hire him. He said, "I hear Joe Sabitini is talking about working for you. Are you serious about that?"

I said, "Very serious, but my view of employment is a lifetime commitment…so I try to make sure I make the right decisions."

"He could really help you on Beale Street," he said.

"Beale Street?" I asked.

"Yes, Beale Street," he said. "I think you could be our co-developer, especially with good people like Joe."

I said, "But Reverend, Joe doesn't know anything about the development business."

"That doesn't matter, he's my friend and you will be my friend," said Smith. I would hear the "friend" comment a lot during the next ten years. After about forty-five minutes, I left Reverend Smith

to join the panel as the program began. "Come s
I took my leave, "we need to talk more."

I would next meet Reverend Smith at his office sever
later. He had already checked to see if any other company
better for the job than E&K. None was, so E&K would be his choice
if he couldn't get Belz. We had just completed the renovation of
Lenox School, which had won numerous awards for adaptive re-
use of a historical school building. We were a company of young
people who were making things happen. Smith also wanted to help
his friend Joe Sabatini, who had agreed to work with us.

There were two other companies in the competition: the
Galbreath Company and Gallina and Bauman Enterprise.
The Galbreath Company, at one time, was the premier real
estate development, leasing and mortgage banking company in
Memphis. Among its alumni was Henry Turley, who became one
of the true heroes of Memphis's downtown redevelopment, but
the company was now a shell of what it once had been. Sonny
Bauman had developed the Coach and Four Hotel on Lamar
and later would promote a horse track for Memphis. The Gallina
family had been a part of Beale Street years before and in a
significant way. Both of the groups had people, but the wrong
people for the job.

Mayor Wyeth Chandler, for whom I had clerked in law school,
was for us, and Allen Boone, with City of Memphis Housing and
Community Development (HCD), felt more comfortable with
us than he did with the other choices. Quite frankly, no serious
developer, Belz or Boyle, wanted to step into this mess. My partner,
Steve Keltner, and I did.

Steve walked into my office one day and said, "Let's go for it."
This was a surprise, but I think he realized that this would put our
company on a different plane.

At the time, Memphis had no tourist industry. The community
and business leaders had a view that tourists were people who were
looking for mountains or beaches. They had not yet understood that
cultural attractions, heritage, food, music and historical sites could
be put together to create a leisure and group tourists market.

. Visitors Bureau was a part of the
.erce. Charley Vergos, the owner of
illard, president of the Junior League,
oup that wanted to change this outlook.
chings: 1) create a separate Convention
cure a method of permanent funding for
develop and promote attractions that could
. a tourist industry.

or Memphis to develop other attractions that would br.. .e and group tourists. The collective attractions first reached na.. nal attention in an article that appeared in the *Houston Chronicle* in July 1983. The article talked about the Peabody Hotel and its ducks—Beale Street, the Lorraine Motel before its restoration, Mud Island, Graceland, the Memphis Riverboats and the Pink Palace Museum. The article talked about Beale Street even before it opened and how tourism was becoming an increasingly important element in driving the Memphis economy. The article expressed, for the first time, a "can-do attitude," which had been missing in Memphis.[22]

> *A statue of W.C. Handy, the Father of the Blues, stands tall and proud in the crisp little Beale Street park that bears his name. Were he alive today, Handy would never recognize the place, for when his trumpet wailed, Beale Street was one of the sleaziest streets in one of the wildest towns in the country.*[23]

In early 1980, the city had begun the renovation of the buildings on Beale Street. The only problem was that it had no end game, no leasing plan, no tenant improvement plan, no marketing plans, not enough money to finish the street and, finally, a totally frustrated coordination between parties. The missing ingredient was a developer who could raise the money to finish the property, lease it, market it and create an organization to bring together the totally dysfunctional group. The city had given BSDC money to pay for a study to tell it what steps were needed to make the development

happen. The study was prepared by Harland Bartholomew, a St. Louis firm that, for most of the twentieth century, had been involved in planning Memphis. The plan for Beale Street was simplistic and uninspiring and was projected to lose serious money: $2,100,000 for the first three years.[24] While Mayor Chandler felt Reverend Smith would play ball with the administration because of his position with AFSCME, there was tremendous suspicion of BSDC by all the working members of the development team.

Despite its potential, the Beale Street development was in chaos. It was a mess. The City of Memphis and its various agencies had torn it down and wouldn't commit to spending any money to rebuild it. They were willing to try to get grants from the state and federal governments, but their goal was to get someone else to invest money into its redevelopment and to take the development off the front page of the local newspapers. The city secured $3,000,000 from the State of Tennessee through the Jobs Conference. The State of Tennessee had one condition: it wanted a developer. It was not going to give the money to the Beale Street Development Corporation, period, because BSDC had no development, leasing or management experience, and because of the problems with the previous executive director.

THE SELECTION PROCESS

As I went to the AFSCME office on Beale and Danny Thomas, I felt good about being selected. That morning, the *Commercial Appeal* did a story about us being chosen as the developer. Each group would have thirty minutes to make their presentations. We went last. As we walked into the meeting room on the second floor, Reverend Smith barked out, "I want the board to know that no one has been chosen and no deals have been made. We are here to accept the best proposal." I would later learn that Reverend Smith was an actor—a great actor! He would often put people on the speakerphone and proceed to chew them out. I came to know

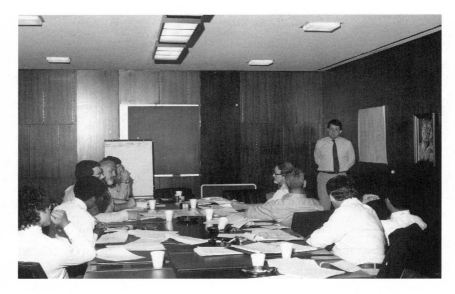

Convincing others to join the Beale Street renaissance was thought by many to be an impossible task.

that there was always someone in the room when he had you on speakerphone.

The key to our presentation was that we agreed to guarantee the money necessary to complete Beale Street and to pay any operating deficit. After the presentation, Reverend Smith called to tell me that we had been selected.

The afternoon paper, the *Press Scimitar*, reported a phrase I used that afternoon that would be our guide for development: "The project must be unique to Memphis if it is to succeed." The article also quoted another of our guiding principles: "Obviously, this project is going to have to be for all of Memphis. Minority businesses will be important to the Beale Street development."[25]

The paper also reported that "the Belz family was to have made a presentation, but the Reverend James E. Smith, Chairman of the Beale Street Development Corporation, said the family chose not to participate for personal reasons." Smith further stated, "Beale Street is the most important project in this community, and I think Beale Street is going to determine whether downtown

Memphis lives or dies. Beale Street can be a cohesive kind of situation that will bring people together."[26] In the article, we also said that the 1984 timetable for completion was unrealistic and that we couldn't see the project being completed before 1985 at the earliest.

That afternoon, WMC-TV Channel 5 news called and told us that we had been chosen. The reporter started the conversation by saying, "How many black employees does E&K have?" Welcome to the public arena, I thought.

The next morning, the *Commercial Appeal* reported that "the Executive Committee, obviously impressed with those guarantees, unanimously picked Elkington & Keltner."[27] Later, on March 8, 1982, the *Press Scimitar* newspaper did an extensive article about Elkington & Keltner that again focused on the project's uniqueness: "When you have a friend visit Memphis, you'll be able to take him to Beale Street and say, this is Memphis."

From the first article, and for the next two years, the *Commercial Appeal* newspaper became a strong ally in moving Beale Street forward. The City of Memphis had been "jacking" around with Beale Street for nearly twelve years, along with the multiple developers, citizen groups and, of course, the nonprofit Beale Street Development Corporation. The *Commercial Appeal* was calling for a conclusion to the Beale Street redevelopment. The editor was like one of the original characters in the movie *Front Page* with Clark Gable. He was a tough, no-nonsense man named Mike Grehl. He was intrigued with Beale Street and what it could become for the city, suspicious of city government and its intentions and concerned about where Memphis was heading. His employer, Scripps-Howard, had a tremendous investment in Memphis with the *Commercial Appeal*, the *Press Scimitar* (which was the afternoon paper) and WMC Radio and television stations.

We had lunch one day at the University Club. Mike said to me, "John, I wanted to meet you to discuss two things: one, to ask you to be the chairman of the annual Christmas fundraiser for the Mile of Dimes, and two, to tell you that the *Commercial Appeal* wants to help you in the redevelopment of Beale Street. We are going to

be very supportive in helping you get this finished." I was excited about both.

We soon learned that other developers thought we were crazy, with one exception—Avron Fogelman. He was the first civic entrepreneur in modern Memphis history. He wanted change. Fogelman encouraged us, complimented us and simply supported what we needed to do. At the same time, he had taken on the task of developing and marketing "Mud Island" and its outdoor amphitheater. He made the amphitheater one of the best entertainments in Memphis during the summer months. The amphitheater showed that Memphians would return to downtown even on hot, sticky nights. Fogelman created the Gold Medallion Club for the amphitheater, which was for individuals who wanted to sit down front, meet the performers and have their own separate bar. It was a huge success.

Memphis Housing & Community Development had hired the firm of Cochran & Sanford to handle public relations for Beale Street. Ron Tate, a former radio executive, had the right energy to help Beale Street get off the ground. He is the one who suggested that

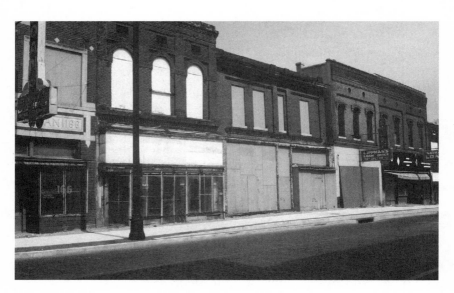

A boarded-up Beale Street in its predevelopment state.

Lou Rawls be our initial spokesman. Cochran & Sanford produced the marketing brochures and helped to develop the initial marketing plan. We switched firms a year into the development, after some internal problems inside the Cochran & Sanford agency, to John Malmo, who took us through the opening and was tremendous in his help—fair, gracious and a true gentleman. We added to this group Norm Brewer, the retired Channel 5 news anchor, as our media consultant.

Beale Street had all of the elements the city was struggling to overcome: urban decay, the abandonment of downtown, a suburban versus urban community debate and questions about the value of rehabilitating downtown and how this city would grow.

In retrospect, we were naïve about people's motives. We thought Memphians wanted change, wanted to see a new, renovated downtown. We believed that Memphians wanted to see the change in race relations that the Memphis in May Festival and other organizations were beginning to help bring about. We thought people would support and encourage rehabilitating downtown.

FINANCES

I promised, during the initial BSDC presentation before the executive committee, to come back within six months with a detailed financing plan. The plan I presented was simple: we needed to put $5.8 million in equity into the development. The cost of redeveloping Beale Street has always been misstated. Additionally, we would not be able to pay ourselves any fees, commissions or reimbursements for at least the first ten years of the redevelopment.

The city inflated what it put into the property to show the importance Beale Street had in the city's scheme of downtown redevelopment. Through the then-nonprofit BSDC, the city secured $2.1 million in Community Development Block Grant and Housing and Urban Development monies from the federal government and $3.8 million in Economic Development Administration funds.

Through the Capital Improvement Program Public Works Budget, the city spent $1.3 million to make improvements to the Gayoso Bayou, which ran under Beale Street.[28] The State of Tennessee contributed $3 million and Shelby County contributed $600,000. Performa put in nearly $4.4 million, and Beale Street sponsors put in $1.3 million. Beale Street tenants, over a twenty-year period, invested $4.3 million for a total of $20.2 million. This is nothing compared to the $63 million that was invested into Mud Island by the City of Memphis.[29] The Mud Island development never reached its potential and had to fight for many years against the fact that it had to be subsidized instead of standing on its own. After Beale Street was redeveloped, it never received any government subsidy.

SECURITY: THE FIRST ISSUE

It didn't take long to realize that crime and safety were what most people focused on when you mentioned Beale Street and its rejuvenation. How we handled this issue would be the single most critical factor in attracting tenants, lenders and customers to a new Beale Street. It was our policy with all critical issues to try and contact the most knowledgeable person in the area and request a meeting with him.

There weren't a lot of entertainment areas in the country other than Bourbon Street in New Orleans, Old Towne Chicago, Underground Atlanta and Le Clede's Landing in St. Louis. There were festival markets at Faneuil Hall in Boston and Harbor Place in Baltimore. There were also retail/entertainment districts at Gaslight Square in San Diego, Trolley Square in Salt Lake City and Larimer Square in Denver.

It was soon clear to us that none of these developments had a comprehensive strategy when it came to security. Underground Atlanta had already failed because of crime in the area. The city never addressed the issue of vagrants, the homeless, skateboarders, boomboxes, teenage loitering and a whole lot of petty crime.

Another problem was lighting. The Underground was underneath the street in downtown Atlanta, so it was naturally dark. In those days, developers and cities used high-power sodium vapor lights, which were bright, but put off an eerie yellow glow. The City of Atlanta was very permissive when it came to handling teenagers with no money just hanging around the area with their high-powered boomboxes whose bass vibrated throughout the development. It also hadn't figured out how to integrate the police and private security. At first, the city did not have a permanent police presence on the street. Only later did it realize that police presence and a police substation were essential. We learned that the other developments also lacked the resources and control that are essential to a safe, secure area.

The next week, after our selection, we hit the ground running. We started to assemble our Beale Street team. In the meantime, we allocated various responsibilities to people in our organization, such as Donna Williams, John Goodwin and Barbara Dufour. Donna would follow up on the details of meetings we had with the city and BSDC to make sure we were "completing" our assignments. John Goodwin would work with me on leases. John Goodwin was Democratic leader Bill Farris's son-in-law and the grandson of John B. Goodwin, who developed Memphis's first shopping center, Poplar Plaza.

Barbara Dufour's job was to help me develop the team. We decided that we needed a general manager, a site manager and an event manager. We would later need a marketing assistant and a chief operating officer. Steve Keltner would assist the marketing people. Thirteen people were involved in getting Beale Street off the ground, and that didn't include the receptionist, secretary or accounting person. Our financial consultant and CPA, Preston Lamm, made an incredible contribution. His initial job was to figure out how, financially, we could build, lease and market Beale Street and how we could generate enough money to repay our investment.

We also had another problem that most of the other urban developments didn't have: Beale Street had a history. While many romanticized the musical history of Beale, the real Beale

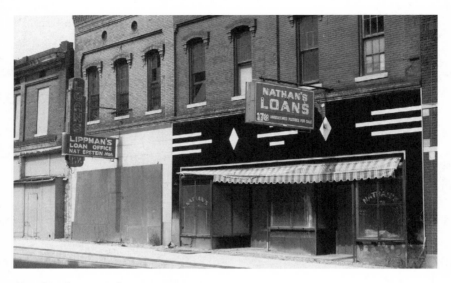

Abandoned stores and empty streets.

of the 1940s, '50s and '60s was pawnshops, crap games, bars and houses of prostitution. Crime, graft and danger were what many people remembered about Beale Street. It also was the center of the marches during the Sanitation Strike of 1968. People still remembered the animosity of that period and the riot that marred the final march Martin Luther King Jr. had on Beale Street.

The first speech I made about Beale Street was to some young mortgage bankers at the Quality Court on Airways and Winchester. Rick Neal at Union Planters Bank had arranged the meeting and assured me that I would talk about the financing aspect of the development. After the cocktail hour and dinner, I began my speech. I talked about how many square feet we would develop on Beale Street, how much we thought it would cost, who our tenants would be and about financing. I also mentioned security and parking.

"Questions?" the moderator asked. The first one was from a young lady. "Aren't you afraid that women will be raped down there?" she asked. I explained that we would develop a security plan that would prevent such a thing. The young lady responded, "If you have a daughter, I hope you won't let her go down there."

Perception, not reality, was what we would have to deal with. In addition, it became clear to me that people didn't believe me when I said that we envisioned a Beale Street where whites and blacks would not only socialize, but also help build the street through ownership and employment. "There would be no barriers, real or imagined, on Beale Street," I said throughout 1982 and early 1983. However, I wasn't sure that Memphians were ready to come together. I wasn't sure if the negative impact of the Sanitation Strike of 1968 wasn't still fresh in the mind of the citizens of the community. I wasn't sure if the injustices and indignities most blacks faced in Memphis were still too fresh in their minds. It had only been thirteen years since Martin Luther King Jr. was assassinated in Memphis.

Memphis in May was a community celebration that was originally organized by Lyman Aldrich, a banker with First Tennessee. Aldrich was one of the first persons to see the development opportunities in downtown Memphis. He built the Front Row Condos, River Row and a number of other properties, all of which showed lenders that downtown had some viability. He was also one of the persons who started the Memphis Music Awards Show, which showcased Memphis musicians in the early 1970s.

Memphis in May helped start to turn around race relations and communication in the city. The idea was to bring together blacks and whites to celebrate the great things in Memphis: barbeque, music and culture. Lyman Aldrich; Tif Bingham; the first black Supreme Court judge, George Brown; Rodney Barber; and Harold Shaw started a celebration that has not only lasted, but has also become one of the major festivals in this country.

The first Memphis in May Beale Street Music Festival was held on Saturday and Sunday, May 14–15, 1977. It was held on the corner of Beale and Third in an area that was falling apart and partially fenced. It was a two-day event that was designed to bring people together. Its subheading was: "The people of Memphis invite you to meet people from Memphis." It included speeches by all the local political leaders, Mayor Wyeth Chandler, County Manager Roy Nixon and Congressman Harold Ford, all on the same stage and all in support of bringing Beale Street back to the

city. The festival also had an incredible lineup arranged by local attorney Irvin Salky that included B.B. King, Furry Lewis, Little Milton, Big Sam Clark, Mud Boy and the Neutrons, Sleepy John Estes and Hammy Nixon. The crowd was the first cross section of Memphians young, old, black, white, panhandler and yuppie to ever party together in large numbers in Memphis. The festival was documented by the actress Cybill Shepherd's brother, Bill Shepherd. It was the type of crowd we wanted for Beale when it opened, with the exception of the panhandlers.

The Sunday program started with a Sunrise Service, which featured Reverend James Jordan of the Beale Street Baptist Church delivering a hopeful sermon calling for blacks and whites to work together to rebuild the city and Beale Street. It seemed to me, as I listened to that sermon, that the racial divide could be closed. I believed that Beale Street could be the catalyst to doing it. It would only take six more grueling years to bring it to fruition.

Reverend Jordan's sermon was followed by a morning and afternoon of gospel music by the Reverend Al Green, Carla Thomas and the Olivet Baptist Church Choir. Later that afternoon, Memphis showcased its great jazz heritage. Phineas Newborn, Herman Green and Honeymoon Garner performed.

Memphis in May had started the reconciliation process in Memphis. It was one of the first steps by young Memphians, black and white, who had gone through the turmoil of the 1960s to assume leadership. It was their first real chance to make change to the community. There were other people and groups—like Jed Dreifus, who had regular meetings at the Little Tea Shop— discussing the race issue. The question was always, "How can we bring people together?" No one had the answer. We knew that we would have to reach out to the black community beyond Beale Street and develop more than advisors. They would have to be advocates for what we were doing. That had been one of the reasons why the Beale Street Historic Foundation, which had preceded Beale Street Development Corporation, had failed. They failed to engage the black community in a meaningful role. To succeed, we would have to become fully engaged not only in building a development, but

also in social engineering. We would have to develop trust among members of the African American community to be successful.

One of the first black leaders I talked to was the Reverend Fred Lofton. In the middle of our meeting, he suddenly got up and closed the door to his study. He sat down, pulled his chair close to mine and then said something I would never forget. "John," he said, "just always remember there is a dark underbelly to Beale Street. It has ruined a lot of good men...prostitutes, drinks, gambling...it can be dark."

Beale Street, at one time or another, had been the center of prostitution in Memphis. Nearly every building south of Beale between Second and Third had once been a "female boardinghouse." A 1920s real estate abstract makes that very clear. Beale Street had illegal gambling, drugs and illegal drinking during Prohibition. The Beale Street Police Museum, which opened during our third year, told the story of daily infractions that occurred on Beale Street during the 1920s and 1930s.

Historically, Beale Street was the center from which the "Crump Machine" controlled the voting of the Negro community and politics not only in Memphis, but also statewide through various polling spots on the street. It was not until the early 1950s that George W. Lee led Memphis blacks away from Crump's Democratic Party to the Republican Party. Lee himself seconded Eisenhower's nomination at the 1952 Republican Convention.

In the 1980s, people had a tendency to romanticize Beale and its musical history, but Beale Street was a rough place. Riverboat crews and sharecroppers came to Beale Street to blow off steam. Gamblers, pimps and conmen were all a part of the Beale Street scene. The weapon of choice was a long knife called the Arkansas "toothpick."

Through the years, we had our share of tenants who had their own legal scrapes with the law, but no one quite like Joe Cooper. Joe Cooper had a piece of four restaurants on Beale Street. One, Cooper's Deli, was bought from Sonia Walker, Joyce Blackmon and Pat Shaw. They were early Beale Street pioneers who had opened an ice cream parlor called Mama Josie's. It was cute, but it couldn't weather the initial drought on Beale Street. Cooper later

got a transplanted Memphian named Royal Johnson to open a club called Club Royale on the corner of Beale and Fourth. He also convinced us to allow him to build a place on Third and Beale called Fatman Joe's. Finally, he got involved with the Mitchells in the dying days of their Willie Mitchell's rhythm/blues club. He would later, with the help of his employer, Bill Tanner the "Billboard King of Memphis," try to open a topless club on Beale.

At first, he tried to bring "lingerie shows" to Beale. This would be his initial attempt to bring a topless club to the area, unbeknownst to us. Brent Perritt, a topless club operator, was Joe Cooper's partner in the venture until Brent kicked Joe out two weeks into the operation. We spent the next three years fighting to get Brent Perritt and his silent partners Bill Tanner and Judge Floyd Peete off Beale Street.

STARTING OVER

GETTING TO KNOW YOU

In the spring of 1983, I began what would become one of the
most difficult things I had ever done. I compiled, with the help
of numerous people, a list of over one hundred black lawyers,
politicians, preachers, businessmen, entertainers and civil rights
activists. I wanted to get their thoughts about Beale Street and
its redevelopment. My knowledge of the black community was
limited, so I went to Lyman Aldridge, John Maxwell, Jr., Pat
Halloran, Calvin Taylor, Reverend Smith, Jack Gibson and others
to help me put together a list of who I should talk to. Quite a
few of the suggestions led to dead-ends and showed that the white
community had no clue who the leaders or future leaders in the
black community were. One day, all of my meetings were dead-
ends. That night, tired and frustrated, I met at Elans with my friend
Pat Halloran to discuss the day's activities. I told him about one
black businessman and pointed out how little he knew about his
own community, to which he responded, "His penetration in the
black community goes no deeper than his wife!"

When I met the people who were suggested, I got them to
recommend more individuals with whom I should meet and talk. I

wanted to make sure I didn't try to sell them, but listened to what they thought was important.

For many, this was the first time they had ever had a serious discussion with a white businessman. Each meeting was at least forty-five minutes long and always at their office, church or home. Most of the meetings were in the daytime, but some were at night, and I learned not to take it personally when a meeting was cancelled, if they were late or if they stood me up. It took me two months to get through the first group of one hundred. I learned a lot from those meetings.

The people with whom I met had definite opinions about Beale Street, what it meant and what the vision should be. George Brown, Walter Bailey, Ernest Withers, D'Army Bailey, Fred Jones and A.W. Willis understood that Memphis couldn't survive without embracing its music, history and culture, expanding the economic pie and developing a political structure that, for the first time, included blacks. Art Gilliam, who is black, owned WDIA Radio Station. His father, H.A. Gilliam, tried to lead an African American group in the redevelopment of Beale Street in the early 1970s. His group, the Beale Blue Light Corporation, lost to the R.P. Brassie group to develop Beale Street in a very controversial decision, which again led to increased animosity in the black community. Art Gilliam was very helpful in explaining the black community's frustration with the city and the way it handled the Beale Street disposition.

I would say first that the group had low expectations about anything happening on Beale. Many people felt that the city would never finish Beale Street. Second, most of the ministers I met, with the exception of Reverend Billy Kyles, Fred Lofton and, later, Reverend Bill Atkins, were out of touch with what course the city should take in the future to make it grow and prosper. It seemed to me that what was emerging was a black middle-class society that was not simply looking to the church or its leaders as had been the case during the civil rights struggle of the 1960s. Their influence as a group was waning, and a political class, led by Harold Ford Sr., was emerging.

Some people wanted to educate and mentor me. A.W. Willis, who was the first black elected state representative, was such a person. In life, someone once said, you may have ten great days. And while I don't necessarily agree with there being just ten, one of the greatest days I ever spent was a spring day with A.W. Willis. It started early one Saturday morning and lasted all day. We drove through Memphis. I showed him the developments we had done, what I wanted to do and what my ambitions were. He shared his with me. We ate lunch at the Four Way Grill restaurant in the back room. It had an incredible jukebox. He wanted to know every thought I had about developing Beale Street. At the end of our meeting, he said, "John, I've told people to leave you alone, and let's see what he's going to do. We as a community are going to have to reach out, and we have to form an alliance with white people to make things happen." We would have many more meetings before and after Beale Street was started.

Later in the day, as we walked around the Lorraine Motel, he would ask me to help him get legislation to support turning the Lorraine Motel into a civil rights museum. Unlike its founder, the visionary D'Army Bailey, A.W. Willis was a practical person and politician. In 1982, the climate in Memphis was not right for a civil rights museum, but A.W. knew that it would take the support of the white business community to make it happen. He would wait until the end of the Alexander term. He also knew that Ned McWherter wanted to be elected governor, and he needed black votes in Shelby County to accomplish that. In fact, in his last year of his speakership, McWherter passed legislation to help fund the civil rights museum.

THE BUILDINGS

One of the reasons Beale Street had not been developed by the other groups before us was because the buildings were in horrible shape. In the 1970s, the city's Memphis Housing Authority had

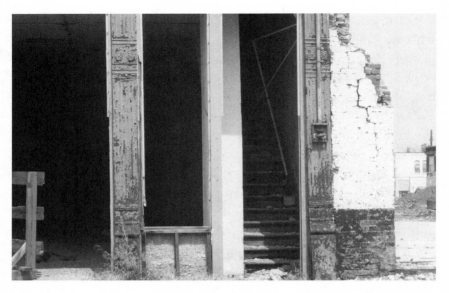

Neglected and crumbling buildings dotted Beale Street throughout the 1960s, '70s and into the '80s.

started the urban renewal process by acquiring the buildings. In most cases, the building owners simply sold their buildings and left. Every building was full of trash and debris. Later, a new city agency, Memphis Office of Housing & Community Development, had boarded up the buildings on Beale to prevent further vandalism and to keep vagrants out. Painted plywood covered up the vacant storefronts.

In essence, what they did exasperated the natural freeze-thaw cycle in Memphis and prevented the buildings from "breathing" in the summer. The high humidity in Memphis increased moisture in the buildings. That caused the mortar between the bricks to deteriorate, the wood to rot and a serious mold situation to occur. Wood ceiling joists rotted, the roofs became unstable and many finally collapsed.

In January 1982, the buildings were in horrendous shape. Number 203 Beale Street was being held up by steel braces. Club Handy, one of the most famous clubs on Beale, was a shell—all that remained were the exterior walls; everything else had been

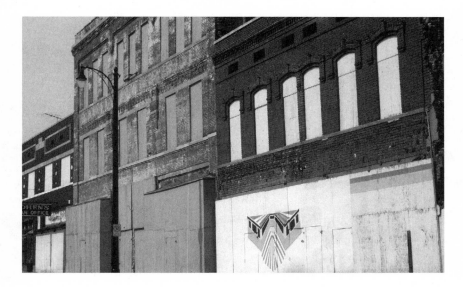

Closed for business.

removed. Number 152 Beale had collapsed, and the three floors were lying in a pile of rubble. There was a good chance the infrastructure and deteriorating exterior walls would soon fall down. It was certainly too dangerous to get any heavy equipment in to remove the rubble. The contractors and architects feared that the slightest vibration would collapse the exterior walls.

The Old Daisy's art deco façade was crumbling away. Most of the second and third floors had either collapsed or were so rotten that in a short time they would collapse. There was serious risk every time an architect, contractor or a member of our group went into a building. The mildew smell permeated the site. My first official act was walking through the buildings one raw February morning with architect Charley Jester and Housing & Community Development's Johnny Owens. It was worse than the architects had conveyed to me. We couldn't walk up many of the building's staircases because they might collapse. "Oops," Charley said one day, "sorry," as my foot went through the second step and my shoe fell off into space. One had to be careful. I walked through the

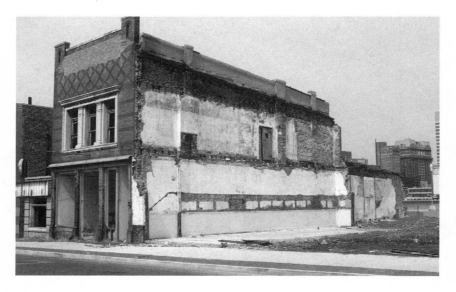

On the verge of collapse.

rubble to retrieve my shoe, which I found at the bottom of the stairwell one floor below. It took us all day to walk through the twelve buildings that remained.

After the trip, I came to three conclusions. First, the buildings were in far worse shape then anyone could imagine. The cost projection we had seen was off by at least 50 percent—it would cost considerably more to get these buildings finished. Second, the buildings couldn't continue to deteriorate. The plywood façade had to be removed. Third, I found out that day that in Charley Jester, and later in Tony Bologna and David Schuerman, we had dedicated architects who had a great deal of pride in Beale Street. Johnny Owens, Al Wesson and Allen Boone of HCD were also dedicated to the success of the development.

I called Allen Boone with my first request. "Allen, we need to remove the plywood from the openings immediately."

Allen said, "We can't do that. There is too much liability if people wander in and get hurt, plus it will make Beale Street look worse."

"Allen, don't fight me on the first thing. We need to do it," I said. The next week, the plywood came down on Beale. We needed to

clean out the buildings. No cleaning had been done since MHA had taken over. They simply closed the doors. There was trash galore everywhere. The city's response was: "we have no money to clean up." I called Bobby Lanier, who was with Shelby County government, and asked him if we could get some inmates at the penal farm to clean out the buildings on the weekend because the city didn't have the money to do it. The next Friday and Saturday, sixty twenty-yard construction dumpsters were filled with trash. Now we could walk in the buildings.

Finally, as a result of the initial walk through, we came up with an additional conclusion. In order to stretch the construction budget, we would create core/shell construction, basic improvement and tenant improvement packages. Core/shell would include tuck pointing the brick, fixing the roof, running electric to a meter box, stubbing in the plumbing, installing a sprinkler system in the building, repairing the windows and doors and fixing the flooring, which was mostly wood. Basic improvements included distributing the plumbing, electricity, sanitary sewer and drains.

Many of Beale Street's buildings had already collapsed internally when reconstruction began.

The debris in the stairwell had to be cleared before construction could begin.

Tenant improvements included furniture, fixtures, equipment and everything else.

The boarding up of the spaces had sped up the decline of the Beale Street buildings and the cost of repairing the property escalated. This created a hole in the redevelopment plan. Many of the buildings should have qualified for a 25 percent historic tax credit. This tax would later change to today's 20 percent tax credit with the passage of the Tax Reform Act of 1987, but most of the buildings were in such bad shape that they couldn't qualify.

This blunder cost between $2.5 to $3 million dollars in cash, which increased the initial dollar amount we had to put in the property. We had successfully salvaged Lenox School in midtown, which had been vacant for years, by utilizing the tax credits as a sales tool. The historic tax credits allowed an owner to get a "bottom line" credit off his income tax equal to 25 percent of the cost of the renovation and other approved costs. This included hard construction costs and soft construction costs (architectural, engineering, et cetera). You were also allowed to sell these tax credits to individuals or institutions that would pay

seventy cents to eighty cents on the dollar for credits. Because of the condition of the buildings, this was no longer possible on Beale Street.

The second major financing problem was a provision in the city charter that prevented the city from subordinating its property to a lender. Since Beale Street was city property, any lender who loaned money would be in a second mortgage position behind the city. This was not an exciting prospect for a lender on a very risky property. The lender's only security was through an assignment of rent, or personal or corporate guarantees. At the time, E&K had more than $3.7 million in cash in the bank and lines of credit in excess of $10 million secured by letters of credit. Before it was over, we would tap every resource and banking relationship we had.

Beale Street had no business plan, detailed development plan, construction plan or marketing strategy for Beale Street. On the day we were chosen, I pledged to the Beale Street Development board that I would have, within six months, a detailed development and marketing study after we executed a signed agreement. While we completed the business plan in ninety days, it would take over a year to secure the contract with BSDC and the City of Memphis.

THE PLAN

In March 1982, we went about developing the promised business plan for Beale Street. We brought this entire group together. We met with the city's Housing & Community Development Department, Allen Boone, Johnny Owens and Al Wesson. Our promotions people, Ron Tate, John Sanford and Norm Brewer; our architect, Tony Bologna; Charlie Jester; David Schuerman; our main contractor, John Heirigs; Cynthia Ham; Davis Tillman; Robert Boyd; Joe Sabatini; Steve Keltner; and myself formulated a detailed plan on how to move forward. At the meeting, Beale Street Development Corporation was represented by Billy Heard, Al James and Calvin Taylor. The meeting was held in one of the

Holiday Inn Rivermont's conference rooms, and for two very long days we developed the plan to move the development forward.

Out of the meeting came a document that established our mission, our goals and objectives and a plan of action. At the meeting, we agreed unanimously, after much discussion between the three major parties—the City of Memphis, BSDC and Elkington & Keltner—that Elkington & Keltner would have the ultimate right to make the final decision if we couldn't all agree. We would be the chief decision-makers. This was a critical change in how the parties had been working. Bologna brought up how George Miller, the previous director of BSDC, had gone berserk several times. One time, he related, George attacked Tony's idea of planting trees on Beale Street, breaking down discussion about everything for several weeks because of his insistence that no trees would ever be put on Beale. It is ironic that twenty years later, George set up a company at the Beale Street Development Corporation's office called the Beale Street Development African-American Reforest Program, LLC.

At that meeting, we came up with the Beale Street Mission Statement. It took hours to distill what all of us wanted Beale Street to be. Once and for all, the statement told the community what we were setting forth to do:

Return Commerce to Beale Street.
Make Beale Street the Live Music Center of the Region.
Beale Street was to be a place where there were no barriers, real or imagined, where blacks and whites could socialize and become party to the economic renaissance we were about to undertake.

It was decided by the group that we needed to set ourselves apart from all other places in the state. Music was certainly the most important thing we could do, but Nashville also had unique musical venues. Unique restaurants would be important, but, as we learned, the movement in the late '70s early '80s was toward chain restaurants. We finally settled on two ideas. One would be fairly easy to attain; the second would be more difficult. We

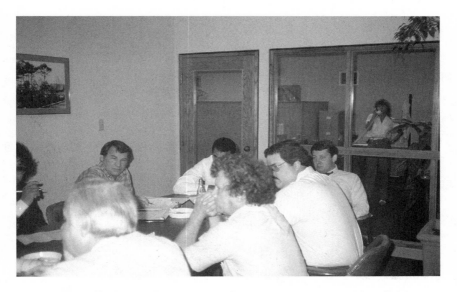

The BSDC and Elkington & Keltner in an all-important meeting with city officials.

would try to get legislation passed that would allow customers to carry drinks on the street. They would then be able to walk from one venue to another with a drink. Bourbon Street allowed it in New Orleans, but nowhere in Tennessee was it permitted. In fact, liquor by the drink had passed by local ordinance in most areas of Tennessee in the late '60s and early '70s. Before then, you couldn't get a drink unless you were in a private club or you "brown bagged."

In a state like Tennessee, passing this legislation would be difficult, if not impossible. I visited a number of people: former State Senator Bill Bruce; my mentor, John Maxwell Jr.; State Senator Jim White; and finally State Senator John Ford. Ford, despite all of his antics, was one of the most effective legislators in Nashville. His ego was enormous. He was outrageous, but very effective. In all the years he was in office, he only asked me once for a political contribution and never asked for any favors. One thing that helped me with John Ford was that Avron Fogelman, my good friend, was his close friend and supporter, as well as a

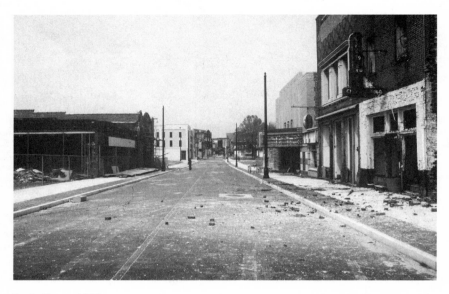

Beale Street, 1982.

contributor to the Fords. Fogelman made it clear to Ford on many occasions that we were friends.

The first time John Ford and I met was when I interviewed to become a member of Leadership Memphis's Class of 1981. We met at the Memphis Chamber of Commerce building next to the *Commercial Appeal* office. Ford was impressed enough to recommend me to the board of Leadership Memphis.

The second time we met was in Nashville, in the office of Ned McWherter, Speaker of the house. The meeting had been set up by Tom "the Golden Goose" Hensley, the extraordinary lobbyist for liquor and beer distributors in Tennessee. Chris Canale, the Budweiser distributor in Memphis, had recommended him to help us with this legislation. Tom Hensley wore a three-piece suit with a gold pocket watch and chain. He carried an unlit cigar and was a ferocious poker player. I liked him. He once said to Gene Smith of the University of Memphis, "Gene, John thanks me before I do something. You don't thank me after I do things for Memphis." In the afternoon, during the session, he would sneak off to a senator's office and play poker with several legislators.

That day in McWherter's office, he was blunt. "John," he said, "you got no chance to pass this bill unless you do everything the Speaker, Senator Ford, Jimmy Naifu and I say. First, you need to visit everybody from the Shelby County Delegation. You have got to make sure that not one of them speaks against it. If they are against it, you have them take a walk."

"A walk," I said.

"Yeah," he said. "Make sure they are not present when the vote is taken. Second, make sure Paul Gurley is not against this. Third, I'll give you a list of committee members you need to visit from around the state. Fourth, do you know any legislators who can vouch for you?"

I named four or five Republicans from around the state whom I had met while helping Robin Bead run for Congress or through Lamar Alexander.

"Shit, don't tell me you're a goddamn Republican!" he exclaimed. "Well, get with the governor's office and make sure they are not going to oppose this. And don't make a big deal about being a Republican!"

For the next three weeks, I visited all the necessary legislators. After several weeks, the committee meeting was held. Memphis Mayor Dick Hackett did not want to take a position against the bill, but he was not going to be for it either. Paul Gurley, the city's lobbyist, wanted to know what the outcome was so he went to the committee meeting, but he tried to remain inconspicuous—a feat that was tough for a man who weighed over three hundred pounds. He kneeled at the end of a U-shaped committee room podium and waited. He wanted to keep up with legislation; he just didn't want to be asked about it.

Senator Ford spotted him and said, "Mr. Gurley, what's the city administration's position on the bill?"

Paul answered, "Senator, we are very supportive of Beale Street, but I'm not sure we have an opinion on this bill."

Senator Ford pressed on. "Are you against it?"

"We are for Beale Street," Paul repeated.

"So I assume by your answer the administration is for it?" Senator Ford asked.

"We are not opposing it," said Paul.

Senator Ford got what he needed and stated, "Mr. Chairman, I move we approve the bill."

"It is so moved and second," stated the chairman. "All in favor say 'Aye.'" We had gotten the liquor bill through the committee. After Paul's stint in city government, he came to work for us in the position of chief financial officer. His and his wife's contributions were immeasurable.

After the meeting, Senator Ford suggested that I take the Shelby delegation out to a steakhouse in Green Hills. "You need to socialize with them," he said. That night, Larry Wade and I took twenty members of the Shelby County delegation out. Tom Hensley, "the Golden Goose"; Paul Gurley, still recovering from the afternoon session; and a friend, Jerry Daniels, a lawyer from Nashville, all helped make the evening enjoyable. The dinner went well. But there was one thing that happened that evening that is still vivid in my mind. Senator Curtis Person, a fine man and later dean of the Republican delegation, made it clear that he supported our efforts, but he basically said, "Liquor has never touched my lips. I'm not going to vote against the bill, but I am not taking a position in favor of it either." Later that night, his wife asked if she could take a $150 bottle of Cognac home. For many years after that, every time I saw him he would remind me of how great the evening was and how much he appreciated it.

The bill passed the state Senate. Senator Victor Ashe of Knoxville was the only senator who voted against it. The next day, it passed the House. Tom Ingram, one of the governor's aides, called me. "It's done," he said. "The governor will sign it." Governor Alexander had now done two things to help Beale Street: he allocated $3,000,000 of Jobs Conference money, and he signed the "Open Container Bill," which allowed customers to carry alcoholic drinks outside establishments on Beale Street.

Senator Ford threw in one more amendment. Beale Street would be exempt from the food/liquor requirement that the Alcoholic Beverage Control (ABC) required. The ABC mandated that restaurants and bars had to have a margin of 60 percent food and

1. W.C. Handy House under construction, 1985.

2. Halloween parade on Beale Street, 1984.

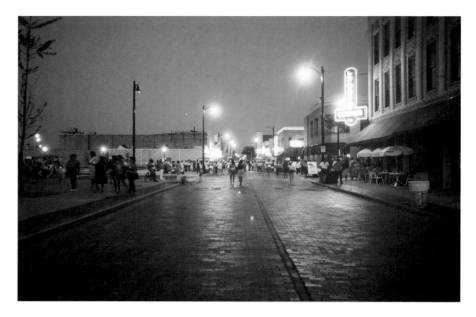

3. An evening stroll down Beale Street.

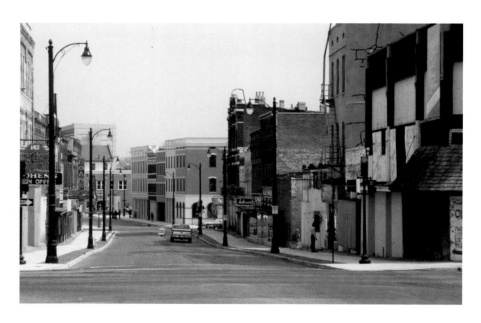

4. The revitalization of Beale Street begins; the newly paved roads and sidewalks will soon be joined by refurbished buildings.

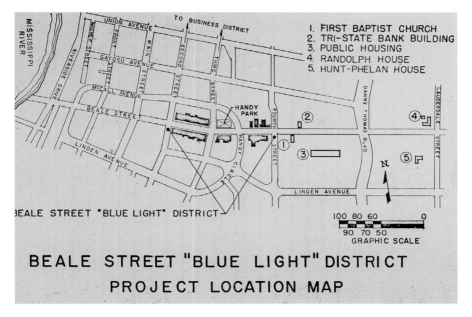

BEALE STREET "BLUE LIGHT" DISTRICT

BEALE STREET "BLUE LIGHT" DISTRICT PROJECT LOCATION MAP

1. FIRST BAPTIST CHURCH
2. TRI-STATE BANK BUILDING
3. PUBLIC HOUSING
4. RANDOLPH HOUSE
5. HUNT-PHELAN HOUSE

5. The city's original plan for area redevelopment.

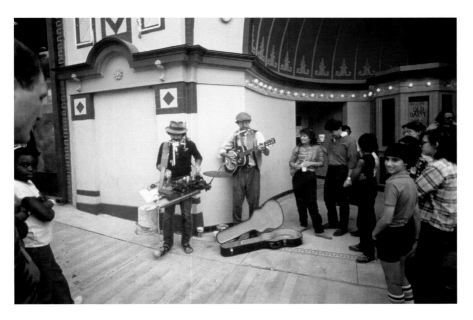

6. A sidewalk concert in front of the Old Daisy Theater, 1983.

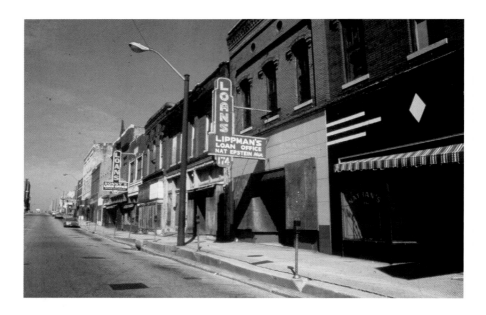

7. In the 1970s and early 1980s, the deterioration of downtown Memphis had begun at an accelerated rate.

8. Beale Street doing what it does best: live music.

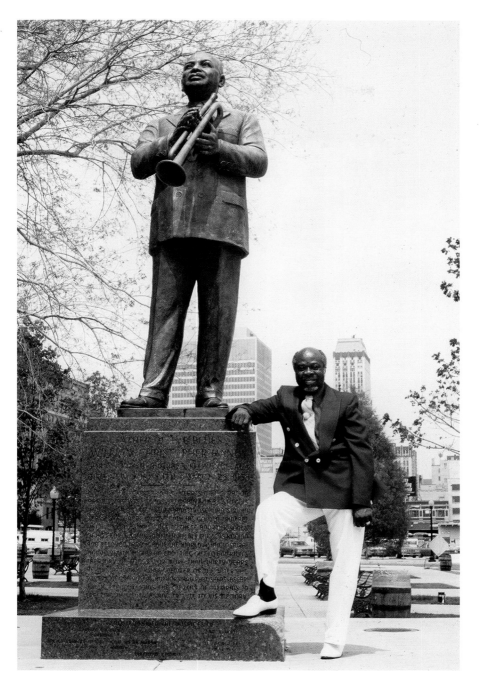

9. A pair of legends: the real Rufus Thomas with W.C. Handy.

10. Beale Street's grand opening ceremony, October 1983. *Left to right*: Reverend James E. Smith, Irma Louise Logan (widow of W.C. Handy), Lou Rawls, Mayor Dick Hackett and John A. Elkington.

11. By the time the 1980s rolled around, the message was clear that something needed to be done to improve the area and protect its legacy.

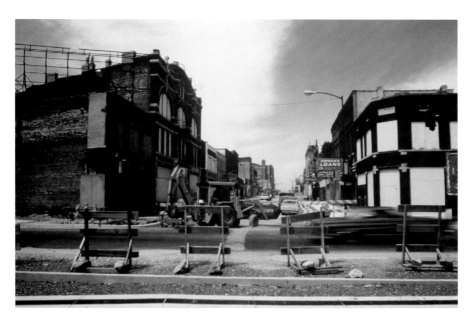

12. Reconstruction begins at Third Street, 1982.

13. Entertainment returns to Beale Street.

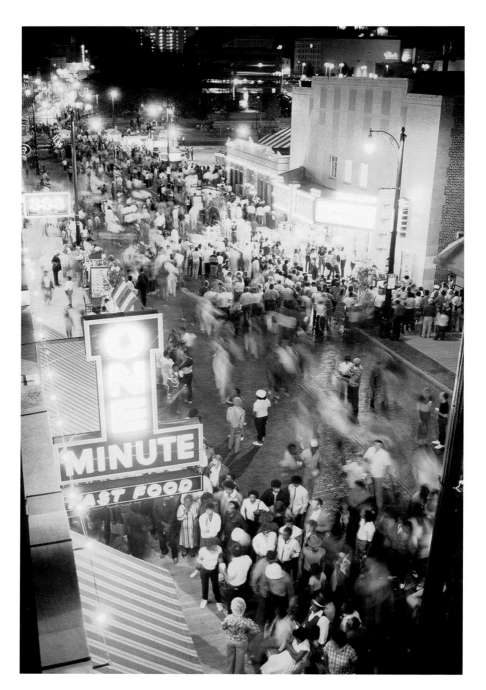

14. Beale Street, 1983.

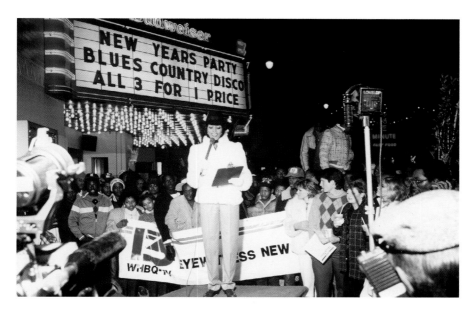

15. When local news channels began to broadcast their New Year's Eve specials live from Beale Street, the urban renaissance was nearly complete.

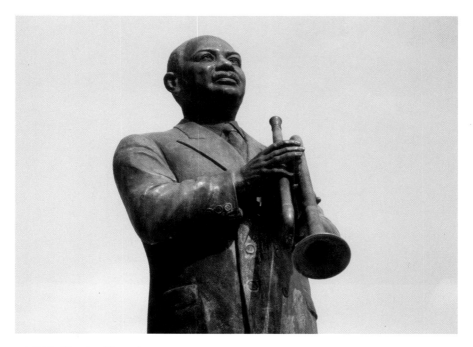

16. W.C. Handy still presides over the street he so famously immortalized in song.

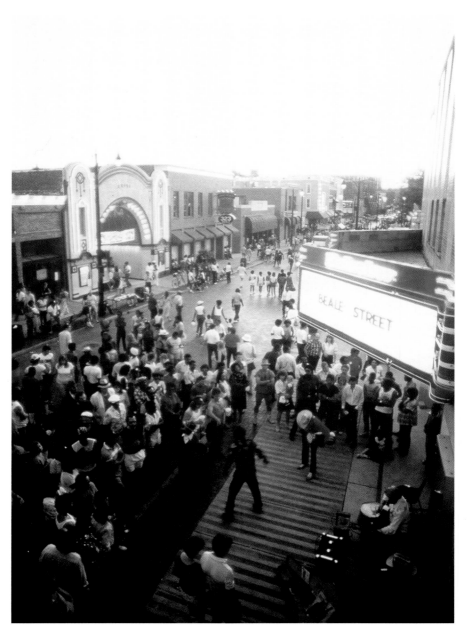

17. A tale of two Daisys: the New Daisy Theater opens across from the Historic Daisy Theater.

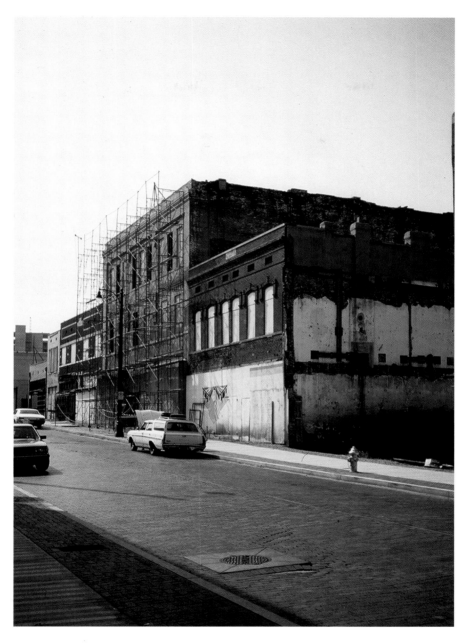

18. By the end of the 1970s, many of Beale Street's remaining buildings were on the verge of complete collapse.

19. Burying the Blues New Year's Eve party.

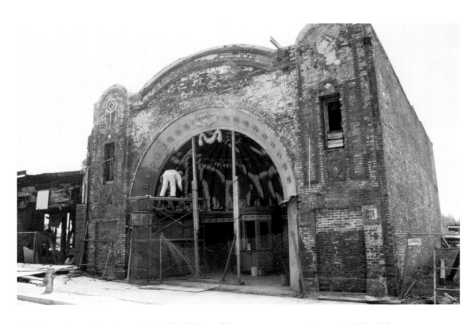

20. A neglected landmark: the Old Daisy Theater gets a much-needed facelift.

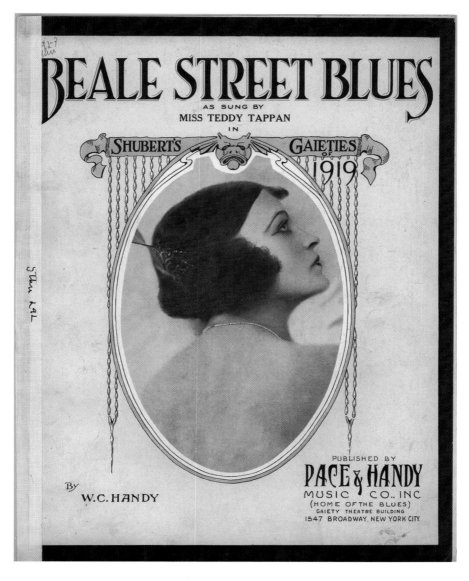

21. Beale Street Blues helped cement W.C. Handy's legacy as the Father of the Blues and introduced Beale Street to a worldwide audience. *Courtesy of the Library of Congress.*

22. How far we have come: today's Beale Street is a product of hard work, determination and perhaps a small miracle or two.

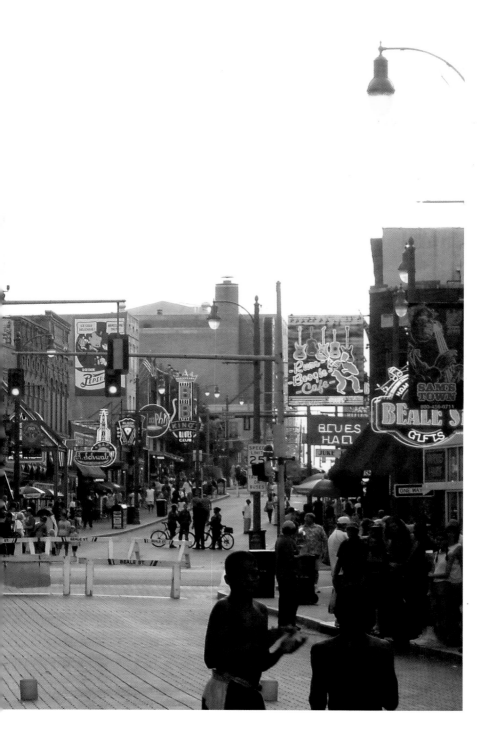

23. A "Tribute to Beale Street" mural, Lansky Building.

24. Beale Street opening day, October 1982.

40 percent liquor. He got a provision through by promising the Nashville delegation the same exemption for Belle Meade. It was included. Armed with the bill, we now had a competitive advantage and would add tremendously to our future revenue. The funds the state, city and county would receive from October 1983 through 2007, including state sales taxes, liquor, franchise and excise taxes, exceeded $40 million. It was a great deal for the state. In August 1994, the Convention & Visitors Bureau called me to tell me that the number of visitors to Beale Street had surpassed every tourist attraction in Memphis.

LEASING

Besides the condition of the buildings, the next perplexing problem was getting the space leased. Early and often in the process, we brought the group together to determine what type of tenants we were looking for. We developed criteria that we still use. The businesses we were recruiting had to have three things. First, they had to be unique. We weren't looking for a chain restaurant or venue that could be found in the suburbs. There was no place for Shoney's, Krystal's or Pizza Hut. As the years went by, we added Chili's, Hooters, Applebee's and the Macaroni Grill to that list.

In 1982, there were few chain restaurants in America; Houlihan's and Friday's were in the first group of bar/restaurants that sprang up in the 1980s and 1990s. Elans, which was developed by Lance McFaddin, was the first club venue. So, when we started, there were "slim pickings" in finding clubs we could bring to downtown. The majority of clubs were locally owned, with independent-minded owners who, at the time, would not "risk the farm" on Beale Street. They would come later.

The second criterion was to find experienced owners who could survive the lack of people in downtown Memphis. We would have to find good operators, help them with the financing necessary to stay open and structure a lease that would help them

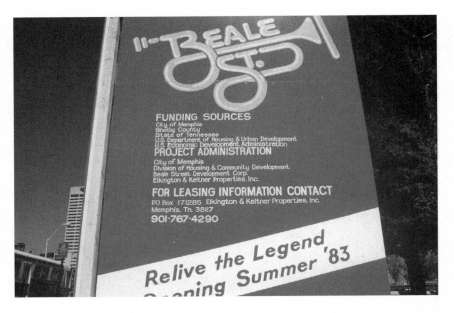

Construction was only one phase of the revitalization of Beale Street; attracting tenants to fill the redeveloped buildings was equally crucial.

survive. We placed real value on operators who had restaurant or club experience. Third, we wanted to make sure that there was significant minority ownership.

It was important that we knew the operators of the clubs/restaurants in the area. Initially, we picked Nashville, the Mississippi Delta, Atlanta and Little Rock as towns or areas in which we would look for tenants. Our thinking was that potential tenants would more readily expand to towns near where they were already located. Finally, we had to have leasing material that was first-rate and credible to give to potential tenants.

Many people felt we should emulate Bourbon Street in New Orleans. Felix Oyster Bar, Commander Palace, Pat O'Brien's, Brennan's, Mr. B's Bistro and Tipitina's were all on our list at one time or another. However, I thought it was a huge mistake to copy New Orleans. We needed to be Beale Street, Memphis—our own destination with our own brands. That was the course I knew would give the property the longevity we needed to survive, but I

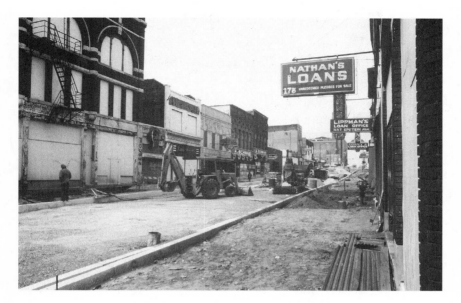

The Second Street and Third Street blocks on Beale Street, 1982.

Construction of Handy Park begins, 1982.

also knew that a Pat O'Brien's would give us local credibility, which we needed. We ran a poll to determine what people thought, and we found, in 1982, that 70 percent of Memphians thought the development would never happen.

Early on, we began to sell Beale Street. We didn't sell it in the traditional real estate way by using a three-, five- and seven-mile demographic radius that would show a prospective tenant the demographics of the area. The demographics were not good enough. We had to sell a "brand." We were selling the music, history and culture of what a revitalized Beale Street could be in the future. Historically, Beale Street had been a music center, not because of its location, but because it was where black musicians could play and earn money playing their music. We wanted it to be fertile ground for musicians, so we had to go out and search for musicians who would help define the new Beale Street. We needed to search out new talent and develop them into local "star" celebrities. We began to assemble our tenant list. I didn't know one musician. I was really only familiar with Eddie Harrison, Reba Russell, The Settler, Prince Gabe and certainly the people who played Paul Savarin's blues club, which was called Blue's Alley, on Main Street. I decided I would go out and learn about every band, what they played and how they could help Beale Street. Food had to play a big part, as well. And Beale Street had to be safe. We couldn't have a place people feared or told their children to stay away from.

Getting the development finished began with getting it leased. At the time, there were five people who could help us with commercial leasing: Cary Whitehead, Larry Jensen, Steve Keltner, John Goodwin and myself. We would later add Robert Boyd, but none of us had experience leasing restaurant space. We didn't know any restaurant operators or any owners of the few national restaurants that were just starting to sprout up in the country. We quickly learned that most local restaurateurs wanted nothing to do with a downtown restaurant. There were no music venues downtown, and Overton Square was the "Big Dog" on the block. They had experienced management in Ben Woodson, George Saig and others and a whole lot of experienced restaurant people who had

grown up at the Overton Square property. I thought that would be a good place to start.

I met with Ben Woodson, who was also working on new restaurants downtown on Mud Island. He had entered into a joint venture with the Pidgen family, who owned Coca-Cola, to develop Mud Island's restaurant venues. He had also opened a restaurant in the NBC Bank building in 1974. The restaurant struggled at night and eventually closed. Wooden was most helpful in explaining what he thought the problems would be. First, downtown restaurants, with the exception of the Rendezvous, would have a tough time drawing a nighttime crowd, except on weekends. Second, downtown needed more attractions, which is why he was hoping we would make Beale Street work. But in the 1970s, Memphis couldn't support two entertainment districts.

Woodson felt that Memphis's Overton Square was the home for the young entrepreneurs and businessmen, and a watering hole for Midtown residents. Friday's and the Bombay Bicycle Club were the places young people went. Both had been tremendously

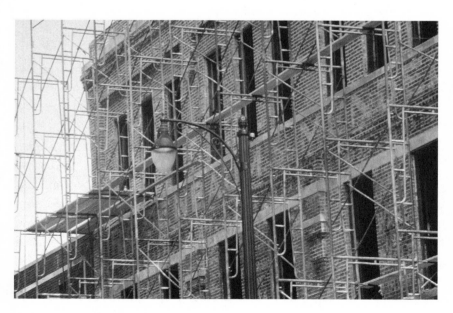

The 152 Beale Street building, 1981.

successful, and Ben and his partners were constantly improving Overton Square. He was also a lifelong Memphian. He had been king of the Cotton Carnival, which was still, at the time, a significant event. He was also founder of the MusicFest, another springtime musical event that initially started at the Fairgrounds, and a part of other civic organizations that were trying to move Memphis forward.

Security and safety was also on his mind. He reasoned that the Rendezvous and Mud Island could be secured because of their location. Even Number One Beale and Caption Bilbo's, which had opened at the river and Beale, were secured on the west by the railroad tracks. On Beale Street, you were exposed on four sides, and two of those sides had security problems. Further, he acknowledged, the downtown economic pie was still very small. Blues Alley and Gene Carlisle's new restaurant, Number One Beale, were additional competition. He summed up by saying, "You have an impossible job. You have the government and a labor leader as your partners, the town is not growing and businesses are moving away from downtown. Midtown is in the midst of a housing renaissance, and other Memphians are moving to Germantown, Bartlett and Southeast Memphis, far from downtown."

Further, Overton Square was not only a landlord, but it also owned many of the restaurants and clubs, and had brought in excellent operators like Silky Sullivan and George Falls, who owned Paulette.

In his office above Friday's, Woodson offered his most important advice. "John," he said, "Memphis is not big enough to support two entertainment districts, and if you can't attract white Memphians to your property, and Beale Street becomes a black development only, it's over for you. You have to attract both groups. You need a balance. No one yet in Memphis has done that. I hope it works, but the odds are against you."

He added, "John, you are going to have to make the decision of whether you want to be in the restaurant business, in case you can't get the tenants you want." At first, we resisted that suggestion

because we didn't want to be both landlords and tenants. We had no experience in the restaurant business, and we didn't want to have the double financial risk of being both landlord and tenant.

As I descended the steps from his office, I realized he was right. Beale Street would be way down the list for the people I needed to attract. They were going to Overton Square, or farther east to Elans in Clark Tower. This was the first time I thought, "What in the world have I gotten myself into?"

BEALE STREET DEVELOPMENT
CORPORATION (BSDC)

After the failure of the Beale Street National Foundation, which had limited the decision-making of black members, the city next turned to the Beale Street Development Corporation (BSDC), which, because it had no development, leasing or management experience, brought in developer Gene Carlisle. Carlisle was a natural choice. He would later develop Number One Beale Street, which was a development that contained a number of retail and restaurant spaces close to the river downtown.

WHO THEY WERE/WHAT THEY DID

BSDC was put together by a group of African Americans who were angry and disgruntled about the way the redevelopment was being handled. The executive director was George Miller, an articulate and charming Arkansan. Miller had gone to law school and was from a wealthy African American family in Helena, Arkansas. He had inherited a considerable amount of rental property and farmland. For all of his virtues, George could be arrogant and dogmatic, and he paid little attention to details. His personality clashed with

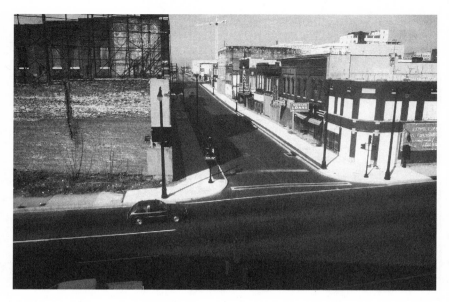

The buildings were not the only aspect of Beale Street in need of restoration; the road and sidewalks also received a fresh paving.

Gene Carlisle, the Beale Street Development Corporation's board and some of its members, but most notably, he clashed with other development team members and the City of Memphis. After a number of embarrassing incidents, including unauthorized travel expenditures and disputes with his development partners, he was removed. He almost brought Beale Street down with him. The final straw was when he was accused of having sex with an underage girl. The city had had enough. Reverend James Netters, a prominent city councilman and chairman of the board, removed Miller.

It was clear that the city never expected us to make it. By the time our lease with the city and BSDC was finally completed, as we got close to the opening of the district, all three parties had developed a way to operate. At the time, we believed that BSDC had no role and would be happy with the good public relations the development was receiving. The city was going to administer the state and federal funds allocated for the property, and we just wanted to complete the task of getting the development finished.

The business plan for Beale Street was an important exercise. It accomplished several things: 1) it brought a group together whose members had no common experience, and it created a commonality between them; 2) it focused on the social mission, which was critical for the city to address at that time in its history; and 3) it sent a message to the community that we were serious, and we were going to finish the job.

What it didn't do was give the Beale Street Development Corporation a real role to play in this development after the opening. In 1982, as we went through the redevelopment, it became clear that BSDC was there for the wrong reason. The corporation was there for window dressing, but it had a powerful black leader, James E. Smith, who wanted credit and power. At the same time, he was happy for us to do all the work. Smith acerbated the problem because he didn't like details and didn't want to press the city on any issues for fear he would use a "chit" he might need for his job as executive director of AFSCME.

We were guilty of not pressing the city to give BSDC a more significant role. However, there were more urgent issues that had never been addressed and somehow needed to be prioritized. There were agendas left over from the "Miller mess." My problem was that I focused on the tasks before us, not the structure. I figured it would work itself out. This would prove to be a big mistake as the years went on. You cannot have "partners" who are not empowered.

I believe the city's housing director, Allen Boone, who had gone through the "Miller mess," felt that BSDC was there for political reasons and was not required to do anything. Allen was a hardworking, sincere person, but he had a tendency to be very stringent in his thinking. He believed that his main jobs were to 1) keep the development out of the paper for any negative reason; 2) make sure the city government didn't put any additional money into it; and 3) make sure Beale Street opened. Not completely opened, but opened with a grand opening event.

Beale Street is a microcosm of our city. We have faced all the issues—crime, racism, cultural diversity and city indecision. After the opening, we were left with the unempowered Beale Street

Development Corporation, which was created without a mission and was put into place by a city administration that had a cooperating ally in Beale Street Development Corporation Chairman Reverend James E. Smith, who needed the cooperation of city government to protect his main employer, AFSCME. Second, no one thought that the redevelopment of Beale Street would succeed—except us. The documents creating the development were shortsighted and one-sided. Instead of changing the documents to create something that would work, the city tried a number of solutions. First, it tried to buy out BSDC. In the late 1990s, BSDC was offered $175,000. The corporation accepted the money, but the creditors of BSDC, including Judge Otis Higgs, who was supposedly owed $50,000 for legal work, wouldn't let BSDC accept the offer unless they got paid. Randle Catron, the BSDC executive director, was frozen into inaction. He couldn't make up his mind what to do, so he did nothing. Twenty-two times, between the years of 2001 and 2006, the city was offered alternatives to the existing lease, and it never responded. The city filed a lawsuit against BSDC in the late 1990s that continues without resolution.

The Beale Street Development Corporation tried for many years to change their position, but their internal disputes, the demise of Reverend Smith and their inability to develop a plan of what they wanted to do severely hindered them. Out of frustration, they sued us three times, and each time they voluntarily non-suited us or the courts dismissed the case. The primary reason was because our lease was very strong and gave us the authority to develop and manage the property. While they told people they had the authority to control the property, they really didn't and this further confused the situation. Their only input was in four areas: pest control, garbage pickup, office cleanup and security.

The other problem they had was that, in 1995, the city didn't want them involved, and in an April 19, 1995 letter, Mayor Herenton said that "the city, by consent of BSDC, will eliminate the role of the Beale Street Development Corporation." Under the lease with the city, the mayor had to approve their budget, and he never would approve it; therefore, they couldn't get funded. The lack of

funding, coupled with a lawsuit between the various factions of BSDC and their inability to define their role, hurt their viability.

In the late 1990s, I felt that if we could work with them to create a community development entity and develop a board that reflected the new waves of black activism, it could help us expand Beale Street to the east and south. This never happened.

Due to the city's lack of success in public/private partnerships, the community's lack of venture capital and the dependence on government subsidies, the city was always trying to change the deal. In 1994, the city set out to audit Performa, questioning the amount of money we put in. During the next two years, nearly $900,000 was spent on lawyers and accountants. All the exercise did was verify the millions of dollars we had put into the development and confirmed what we had told them was correct. They never released a report. The *Commercial Appeal* wrote the city asking for the results of the audit under the Freedom of Information Act. They received the following reply from Robert Lipscomb, director of housing and community development:

> *There has been no such report, partial or otherwise, submitted to the Memphis City Government by accountants Coopers & Lybrand or Banks, Finley & White. Charlie Newman and Ricky Wilkins were hired by the City of Memphis to provide legal assistance…but were not engaged to perform any audit of Beale Street management.*

During that time, the mayor contacted every major mall developer (Simon, Hahn and Urban Retail) in America, clearly showing the lack of understanding of what Beale Street should be. One of the letters was sent to Ross Glitman, chairman of Urban Retail. Fifteen years later, Ross and I worked on a development in Memphis. Ross wrote a letter in May 2007 that said, "John I marvel at what a wonderful job you have done with Beale Street. The vision, choice of tenants and the programming is wonderful. You should be extremely proud…you created a special place and we look forward to working with you in the future."

GETTING THE TENANTS

KUBLAI KHAN'S

In the beginning, we received information about prospects from friends. For instance, Judy Peiser, who was with the Center for Southern Folklore, told us about Bernard Chang. Bernard owned a Chinese restaurant on Winchester Road near the intersection of Lamar Avenue. He had originally been an accountant who wanted to own a Chinese restaurant. He wanted to get off of Winchester Road and become part of our development. Historically, there had been a Chinese restaurant on Beale Street called the Chop Suey House. No one knew much about it except that it had been there for some time.

After several meetings, we made the decision to make a deal with Bernard. We spent most of our meetings in the evenings eating and talking. Bernard was always a good host. One evening, as we finished eating, he suggested we toast with Chinese liquor. We did this many times after that. It tasted like gasoline, and boy was it potent!

The next morning, at the office, I asked Joe Sabatini what I had agreed to because I couldn't remember. Joe couldn't remember either, so I picked up the phone and called Bernard. I said, "Bernard,

I want to go over what we agreed to." I found out that I had agreed to give him what was the best location on Beale—the southeastern corner of Beale and Third Streets. But at least it was a start.

Armed with the ingredients we thought were important—music, food and inclusion—we set out to find the right mix of tenants. The first list we developed included B.B. King's; Doe's Eat Place in Greenville; Lusco in Greenwood; Pat O'Brien's, to give us a little New Orleans flair; Charlie Rich; Tipitina's; Lafayette's Corner (we wanted the most popular bartender in Memphis, Lafayette Draper, to have his own place); and the Vergos family needed to have a place. Charley's daughter, Tina, worked for Elkington & Keltner at the time. I had gone to law school with his son John and was good friends with his son Nick. I ate at his restaurant, Rendezvous, at least twice a week. It seemed natural to me. We also wanted a great Italian restaurant, so we went after Ronnie Grisanti, who, at the time, had a restaurant in an old building next to Sun Records at 706 Union Avenue. Lou Rawls, who was our new spokesman, wanted a club. We wanted a great seafood restaurant, and we needed clubs. Jake Schorr was the only club operator in downtown Memphis, so he was our first challenge. Finally, we needed retail.

We had no clue who would want to establish a retail business on Beale Street. The only retail in downtown at the time was a fading Goldsmith's Department Store, a couple of ethnic clothing stores and a number of wig shops.

B.B. KING'S/DOE'S EAT PLACE

I started my quest for a B.B. King's Blues Club in June 1983, just after we had taken over Beale Street. I tried for several months to get an appointment with B.B.'s manager, Sid Seidenberg, but to no avail. Sid was a wonderful man, tough and very protective; a man who believed in a five-year plan—the five-year plan he was working on. He had no plan for a club. Later, maybe, but not now.

I was determined to get B.B. King, who was, even in 1982, the "King of the Blues." It would take me seven years to accomplish that feat. During that time, I had over twenty meetings with B.B. or Sid, or both B.B. and Sid. They told me absolutely no for nearly three years, but I persevered, I didn't quit. Every time I went to New York, which in the 1980s was at least once a month, I visited Sid. I would always call him and say, "Sid, John Elkington. I'm in town. I wondered if I could come by and visit with you and pick your brain. I know B.B is not opening a club, but I want to tell you what I'm doing and how it's going." Then, the pause. "Okay, but only for a few minutes," he would say.

At first the meetings were short and Sid was aloof, but after several years he became a great advisor and friend. I mainly listened to his great stories. He told me about sitting for hours at the coffee shop in the Hilton Hotel in Las Vegas, hoping to meet people who could help B.B. move from a lounge act to a headliner. He would set up meetings with promoters and other managers. He would fondly tell stories about Elvis Presley's manager, Colonel Parker, who, like Sid, would hold court in the coffee shop at the Hilton. Over the years, he met waitresses who knew everyone and would help him make introductions. There were many similarities between Sid and the Colonel. According to Jack Magids, who represented Colonel Parker and later litigated against B.B. and Sid for Tommy Peters, they both had complete control over their clients. Both loved negotiating the smallest points, and both stayed away from managing other clients because of their commitments to Elvis and B.B. At one time, Sid represented Gladys Knight and Gene McDaniels (*A Hundred Pounds of Clay*), but he gave them up to manage B.B.'s career.

In addition to meeting with Sid, I met B.B. King in Natchez, Jackson, Indianola, Reno, New York and countless other places during my seven-year courtship. B.B. is the kindest, nicest person I've ever met in show business. He is generous, thoughtful and interesting, but he wouldn't do anything without Sid's approval.

During the early 1990s, we finally moved toward completing the deal. B.B. King would agree to a club on Beale Street. There was

only one problem: I didn't have an operator or the money, and Beale Street was not yet a success. This added to the fact that I had just spent four years working from near bankruptcy, a divorce, a breakup with my partner and our investors, and I was just starting to eliminate all the lawsuits and liens that had been filed against Elkington & Keltner. Steve had filed for bankruptcy, but I was determined not to. I was ready to move forward with the next great push on Beale Street and secure B.B. King's and Doe's Eat Place all in the same year.

We met in the fall of 1990 in New York at Sid's office. "Sid," I said, "Beale Street is ready for B.B. King."

He said, "People have sent me these articles about your company and your personal problems. Can you pull this off?"

For the next two hours I told him every detail of my life. I was in bad shape in 1988. Elkington & Keltner's cash was taken away by our controlling partners, and we were left with $120,000,000 in debt and $18,000 in the bank. I was forced to bring together all of our lenders, creditors and employees to tell them I would pay them off if it took me five years to sell all of the property, liquidate the individual debts, pay off the government and start a new business. At the same time, we had to promote Beale Street, lease the space and improve its image. Things began to change when three events occurred: 1) Rita Grimsley-Johnson, a columnist with the *Commercial Appeal*, wrote about the patina wearing off Beale. It was a glowing article. 2) *U.S. News and World Report* picked Beale Street as "the second best bar hopping place in the county." 3) For the first time, the State of Tennessee reported that more people who filled out cards at the State Welcome Centers said they were coming to Memphis because of Beale Street instead of Graceland.

At our meeting in New York, I told Sid, "People said Beale Street would never work, it would never make it, that I wouldn't make it. I would go bankrupt and I would lose the lease." I continued, "Sid, we have overcome all of these things. We have finally turned the corner. If B.B. will come to Beale Street, this project would be secure and it will flourish. Sid, you can make it happen. Let's build a B.B. King's Blues Club in Memphis."

Sid said, "Yes, I think you're right. Now is the time." He then picked up his phone and called his lawyer. Sid and I agreed on the basic terms. We set up a meeting in two weeks to prepare the documents. I prepared a five-page letter about the structure, terms, the parties, responsibility, warranties and representation, B.B.'s appearances and what would happen if B.B. died.

The operator came first. George Eldridge was a restaurateur from Little Rock, Arkansas, and was one of Bill Clinton's best friends. He was there the night Clinton lost the Arkansas governor's race to Mark White, and he was at the old state capitol in Little Rock, Arkansas, the night Clinton was elected president. He had a long history as an entrepreneur and owned the Doe's Eat Place in Little Rock, Arkansas. I had put Doe's on the original list of potential tenants in the spring of 1983. I was first taken to Doe's in Greenville by my then-wife Jo Cathy in the late 1970s. Owned by the Signa family, it was a terrific place. It was a house that was divided into numerous rooms. The kitchen was in the center of the house and was where the salads were prepared. The steaks, all three, four and five pounds of them, were cooked in the front room as you walked in. Steaks, salad and hot tamales were the bill of fare at Doe's. I remember lying on the beach at Destin and hearing people talk about Doe's. I decided right then that we should leave the next morning and drive to Greenville to eat at Doe's, instead of going home to Memphis.

For a year we were in a battle to bring Doe's to Beale Street. The people who owned Overton Square also wanted Doe's. Overton Square had been the entertainment Mecca of Memphis for many years. The ownership thought they were invincible, but I convinced George that, while they were more popular now, things were beginning to happen on Beale Street that would change our position. He agreed with me.

In 1991, Beale Street finally fulfilled my dreams: Channel 5's New Year's Eve Show was moving to Beale Street, B.B. King's Blues Club was opening and adding Doe's to our tenant list would be the beginning of the end for Overton Square. Later, through

mismanagement, miscalculations and arrogance on their part, we overtook them.

George agreed to move to Beale Street when I asked, "What if you ran B.B. King's too?" For a blues lover like George, that was too much to resist. He agreed to sign the lease, and Beale Street now had Doe's Eat Place, B.B. King's and an operator. Just one small problem: we didn't have an investor.

Two weeks later, after several phone calls to discuss my memo, which consisted of several pages, I returned to New York. B.B. King's lawyer was not an imposing individual. He was slight in both build and weight. However, he had an extremely quick mind and asked endless questions to determine what the circumstances would be if and when the club came to fruition. On my first day in New York, we met for seven hours and broke for a late lunch around 3:00 p.m. I had not scheduled a return trip because I wasn't leaving until the deal was complete. I asked him if he would feel more comfortable if I drafted a license agreement. His response was no. I tried to get him to draw up a letter of intent. He said, "This is my interpretation of how the deal should be structured. It is not necessarily everything we've talked about."

"I know," I said, "but I plan to discuss the points and would like to meet again tomorrow at 8:00 a.m. Let's get some lunch."

"I'm not hungry," he replied, "But, I would like to walk and discuss this further."

Hoping I could grab something to eat on the street, I agreed. Phil Kantor was a prolific walker. We started at Fifty-sixth Street.

Two hours later, in ninety-degree weather, we reached the United Nations headquarters. We sat on a stone bench outside of the building. By now, I was soaking wet. I asked, "Phil, is this the way you negotiate—walk the other party to death?"

"No," he exclaimed.

"How do you stand the humidity with your yarmulke and black suit on?" I asked. I had taken my jacket off long ago. "Would you like an ice cream cone?"

He said, "No, I'm Orthodox. We don't eat ice cream." Great, I thought. What a faux pas—that's a basic thing I should have

Beale Street's resurgence was aided by events like the city's New Year's Eve celebration.

known. We finished up our discussion and then he asked, "Why don't we go back to my building through our client's buildings?" The buildings were spread over several different streets. At the end of our odyssey, we got to his building.

"I will report to Sid that we have a deal. It will take me three or four weeks to memorialize it," Phil said.

"Great," I said.

Two months later, in B.B King's room at the New York Hilton, we signed the license agreement to open a B.B. King's Blues Club in Memphis.

My friend Rudi Schiffer, who was our public relations person, went with me to New York to call back the story to the *Commercial Appeal*. Sid Seidenberg, B.B., Rudi and Floyd Lieberman were present when we signed the agreement.

Since we had no capital to build the restaurant, I had to find someone who could raise the money to build the B.B. King's on Beale Street. Tommy Peters owned a company called Progressive Capital. The company raised capital for ventures ranging from hotels to airplane parts, but he had never done a restaurant. When I first met Tommy, he said there were only two things preventing him from raising the money: people who had money would probably not invest it in Beale Street, and the same people probably would not invest their money in a restaurant. But Tommy was willing to move forward and raise the money, which he successfully did.

George Eldridge, of Doe's Eat Place in Little Rock, and Tommy still had to enter into a management agreement, and we still had to build it, but we had bagged the biggest deal in the history of Beale Street. We opened the club the weekend of the Beale Street Music Festival. B.B. King couldn't play because the contract he signed with Memphis in May prohibited any other performances before or after his show. It didn't matter. Jeff Haley, John Lee Hooker and Ruby Wilson performed, and the crowd was thrilled with Memphis's newest attraction.

The *Commercial Appeal* and all of the television stations proudly announced that B.B. King was back on Beale Street. Finally, they

realized that Beale Street wasn't going away. The opening of B.B. King's across from Doe's gave me a sense of accomplishment that I hadn't felt for a long time, but I also had an emptiness that I guess came from working on something for such a long time and then finally seeing it fall into place. It was almost anti-climatic. Standing out in the street with Joe Sabatini, Al James and Mike Hjort, looking up at the neon B.B. King's Blues Club sign, I said to Joe, "There must be something more than this. I don't feel like I thought I would."

"It's natural, don't worry about it. Enjoy the moment. We are turning the corner," Joe responded.

ALFRED'S

The first time I met Johnny Robertson, the owner of Alfred's on Beale, was at Alfred's original location on Raleigh LaGrange Road, near Bartlett. Beale Street was still struggling, but there had been some signs of life. We had an increase in our gross income, and our spring and fall music festivals were both successful, but that was it.

Johnny was a smart businessman. Over the years, he had his ups and downs, but he was very intuitive about the restaurant business. At the first meeting we had about him opening a restaurant on Beale Street, he had already made the decision to come to Beale. This meeting, to him, was to simply decide what building he would go into, how much it would cost and what our deal would be. This was something I wasn't used to.

I started my spiel about Beale Street, tying together every good thing I could think of. Johnny had three or four appetizers sent to our table during this talk. At the end of our meeting, he asked me, "When can we sign the lease?"

I was stunned. "Johnny don't you want to visit the building?" I asked.

He said, "I have visited Kublai Khan's before. I will need to make some changes, but it's where I want to go."

I said, "It's probably going to cost you $100,000 to make those changes."

"I know," he said in a matter-of-fact way.

"Do you have the money?" I asked.

"No," he said, "but I can get it."

I said, "If you borrow the money, the loan will have to be subordinate to the city's position."

"No problem," he said. "I have a line of credit at Commerce Union Bank."

Until that point, no bank had invested in a Beale Street restaurant. Later, First Tennessee Bank, First American, Union Planters, NBC and SouthTrust Banks would all eventually loan money to businesses on Beale. However, Commerce Union would be the first bank to commit to a business on Beale. They didn't loan the money for a Beale Street restaurant, they loaned the money to Johnny because he had built up assets on Raleigh-LaGrange Road. He was risking all of that for his Beale Street dream. He was gambling on our vision that Beale Street would someday be what we had hoped it would be.

That same night, Johnny brought his two small children, his wife Sandy, his mother and his brother to look at the recently closed building. Sandy recalls her apprehension and the smell of rotting food in the kitchen. "We'll be eating a lot of sandwiches over the next several years," she said. Johnny responded, "I know but we'll make it."

Johnny was a gambler who lived on the edge. However, he picked good people to work with him. Chuck Oswalt, who would spend his adult lifetime on Beale Street, was his general manager. He made sure that things worked. His main job was to make sure that Johnny had enough money to do the things he liked to do, such as travel, gamble and help other people. Chuck made sure that Johnny's wife, Sandy Robertson, and their two boys were taken care of. Johnny picked great rock n' roll bands throughout the years, and he consistently expanded his business. In 1987, he added an atrium in the back of the building. In 1995, he built a deck, and throughout the years, he consistently added to, and improved, the property.

In the mid-1990s, he hired George Klein, Elvis Presley's disc jockey, and added the Elvis Room, with some of Elvis's gold records and pictures of the King. It would be a fixture over the next fifteen years. He had an annual Elvis Week Tribute, during which George would tell the faithful about Elvis and his music.

In 1991, Johnny secured Mama Josie's, which had closed, and Lafayette's Corner. He combined them into one space—Joyce Cobb's. Joyce was a wonderful person and a Memphis singer. It became the home for the Memphis Jazz Orchestra every Sunday night. They brought the big band sound to Beale Street, and an older crowd that liked Joyce and jazz, but which had not yet experienced the renovated Beale Street. The food was good and the entertainment was great, but like many of the early clubs, there was not enough critical mass to help sustain the business. In the late 1990s it would have survived and grown into a much bigger entertainment package.

THE CENTER FOR SOUTHERN FOLKLORE

Later, in the 1990s, Johnny gave up on Joyce and we gave the space to the Center for Southern Folklore, another great attraction, but a poor financial operation. It was the center's third location on Beale Street. Judy had been on Beale Street since it reopened. Her first location was the Old Daisy Theater and then later the Lansky's Brothers clothing store building, before Elvis Presley Enterprise leased it. I had, from Holiday Inn, FedEx and other Memphis companies, raised $150,000 to help Judy build the Center for Southern Folklore headquarters at the Old Daisy on Beale Street. It was a magnificent building and the initial interpretive film, which was paid for by Holiday Inn, was excellent. I remember, in the spring of 1983, being in New York and getting a call from Judy, who said, "You won't believe the film for the center. Can you come by and see it?"

I got in a taxi and went to the production office on the west side of Manhattan to see the film. It was great! Judy hooked me further.

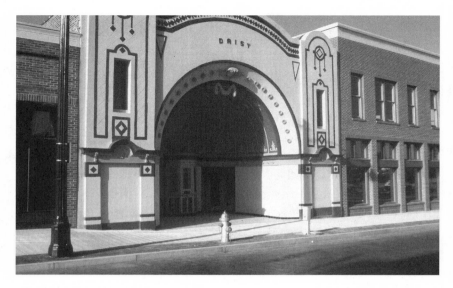

The Historic Daisy Theater.

She asked, "John, would you be a member of my board? If I had additional funds, I could do more things like this." I joined her board, and Judy would do the same thing she did with me to others, which was get them hooked on the Center for Southern Folklore. I became, for a short time, the "go-to guy," an easy position to fill because my good friend Richard Rossie was also her lawyer and close friend. When I got back to Memphis after seeing the film, I got a call from Judy.

"I have a real problem," she said. "I'm behind on a $50,000 note at First Tennessee Bank. I can't pay it."

I said, "Judy, it doesn't sound like you have the problem. It's the bank that has the problem."

She said, "I thought they would make my loan a contribution. Could you visit the branch manager at First Tennessee Bank on Cleveland and try to work it out?" she asked.

Before I went, I called Richard and asked, "What's the story on this loan at First Tennessee?"

"What loan," he asked. "Judy never told me about a loan. How much is it?"

"I don't know, she couldn't tell me," I said.

He asked, "Is there any collateral pledged?"

"I don't know," I said.

"Did she sign personally?"

"I don't know."

"When did she make it?"

"I don't know. In fact, I don't know anything except that she says she is in default."

"Let me know how your meeting goes," he said. "You know John, Judy is a very talented person, but she operates differently."

I proceeded to meet with the branch manager at First Tennessee. She quickly told me that indeed the loan was in default, but she couldn't discuss the terms or conditions with me. I decided to call Carol Coletta, who had been one of our earlier supporters on Beale Street. Carol worked in the communications department at the bank. I said to her, "Carol, apparently the bank loaned Judy Peiser $50,000 and the loan is now in default. She can't pay it. Is there any way we can make this loan go away, make it a contribution?"

She responded, "No, John, that would be a huge part of my budget and it's a loan. But if we don't pay the loan off, it will go against our earnings."

I asked, "Could you see if it's possible? Maybe the bank could give Judy a contribution that she could use to pay the loan off." Eventually, that's what the bank did.

Early in her career, Judy had been very creative in securing historical archives and produced key footage about Memphis's and the Delta's musicians. She developed or secured key photos of the era from Ernest Withers, the Hooks family and other photo collectors. Her original work was great. She attracted all the right Memphians to her board, including Jack Belz, Don Sundquist, Richard Rossie and other prominent businessmen, lawyers and bankers. But Judy was a poor operator. Originally, Bill Ellis, who later formed the Center for Southern Culture at Ole Miss, worked with her. He knew how to promote the center and get contributions, and how to keep the grants coming in. He was also a terrific operator, which was a good balance to what Judy did. Regardless, Judy filled the

space perfectly. She developed a very unique shop made up of folk art; Southern junk food, like Moon Pies and RC Colas; and a unique brand of entertainment, which was pure grass roots.

Our arrangement with Judy was simple. The center went from one crisis to another, but there was something magical about it. Plus, who is against saving our history, music and culture. I credit Judy with exposing me to the wonderful culture we have in our region. When we started Beale, we knew music was important, but it's the culture and history that are so critical to a development like Beale Street.

THE GRAND OPENING

OCTOBER 1982

The first crisis on Beale Street occurred a few weeks before our opening date. George Miller, still smarting from being forced out at BSDC, hired people to pass out flyers downtown and in the black community that urged, "Don't let the whites takeover Beale Street. You deserve a job there. Come down and sign up for a job this Friday at Handy Park." In addition, he sent word that black Muslims were going to disrupt our grand opening. Joe Sabatini alerted his friends at the police department. He took this very seriously. In the meantime, Reverend Smith was also concerned with George's erratic behavior. "Joe," he said, "I have a friend who is a black Muslim and was in Leavenworth. He wants to help defuse the situation."

Joe said, "Let me check these guys out." He called a deputy director at the police department who confirmed this was for real and that these Muslims were just out of prison. Reverend Smith's friend was just out of prison also and was working as an informant for the police department.

Reverend Smith, Joe and John Goodwin agreed to meet him at Ruby Tuesday's across from our Chickasaw Gardens development.

Joe asked me, "Why don't you meet us later?" Their meeting was scheduled for 6:30 p.m. I arrived at 7:30 p.m. John Goodwin was already in a heated conversation.

By the time I got there, Joe, John, Reverend Smith and the informant already had three or four drinks. Joe was drinking Jack Daniels with a splash, John was drinking vodka on the rocks, Reverend Smith was having the usual fifteen-year-old Glenlivet scotch and the informant was drinking Courvoisier. The testosterone was flowing. The informant was talking about what he was going to do.

John told him more than once, "You're full of it."

"They're bad," the informant repeated. "Tougher than any of you."

John, who lifted weights every day, took this as a challenge. "Man, you're full of it. They're not going to do anything."

The informant replied, "I don't care about you guys, but Reverend Smith tells me Joe is his friend. I'm going to take care of him. They're not going to bother you."

"How are you going to take care of them?" Joe asked.

The informant answered, "You don't need to know."

John asked sarcastically, as he rose from his chair, "What are you going to do, whack them? I'm tired of this BS. I'm leaving."

Joe said, "Now, we don't want any violence. We just don't want them to interfere with our opening."

The informant responded, "I'm going to take care of them, and if I get caught, I will deny you had anything to do with it."

Joe was starting to panic. "Deny what?" he asked. "I haven't told you to do anything."

The informant winked. "Right, they won't be able to trace anything to you."

"Wait," Joe pleaded.

"Joe," I said, "you don't think that guy is going to whack them do you? Did he understand what you were talking about? There is no communication problem is there? Joe, this is not good." Nothing happened because Joe called his friend at the police department, and they had the informant picked up at the Admiral Benbow

Senator Howard Baker
takes in the grand opening.

Defying the odds, Beale Street's grand opening ceremony was a defining moment in Memphis's history.

Inn on Union. Miller's rally fizzled, and we moved on with the grand opening, which came nearly two years after we joined the development team and nearly five years after the city began developing Beale Street with BSDC.

The opening that the city wanted to push had been postponed once because the street, which was brick, was now coming apart. The bricks had been laid on Beale in a bed of sand. It looked great until trucks were allowed to drive on it. The bricks began to shift, coming up and sinking down. At first, city officials simply thought that the street was settling, but it got worse. I called Dick Hackett, who knew how to handle these types of complaints after many years as director of the mayor's Action Center. "I'll meet with them and we'll walk the street," Dick said.

Dick, Al Wesson, Robert Boyd and I walked the street. "Who is responsible and how quickly can we get it fixed?" Hackett asked. Al didn't know. "Find out and let's meet tomorrow. Call the architect. Tell him he will never work for the city again if he can't get this job done."

This delay cost us precious summertime activity. I remember going with Rex Dockery down to Beale to look at the progress. "When is it going to be finished?" Rex asked as he looked at the sand on the street and the bricks on pallets on the sidewalk. The city said a couple of months—it took four and a half.

THE RUM BOOGIE CAFÉ

How It Saved Beale Street

In the summer of 1985, Beale Street was struggling. We were having difficulties keeping clubs and restaurants operating successfully. One of Beale Street's first clubs, Memories, was designed by restaurateur Otto Gross. The club had great food, and the waiters and waitresses sang throughout the night. It was a terrific concept, and they had unbelievably talented employees, but Otto contracted cancer, and the restaurant, because of its location on the street, had a tough time.

Lafayette's Corner, owned in part and operated by Lafayette Draper, went into a five-year death spiral. Sandy Carroll, a pianist who was one of the greatest singer/songwriters in Beale Street's history, played at Lafayette's Corner every night, sometimes to crowds of five or fewer people. Kublai Khan's, Tempo's and Club Handy were all good concepts with good operators. Cindy Ham and Davis Tillman came up with unique marketing ideas. But we weren't drawing people to downtown. I remembered what Ben Woodson had said to me earlier, "You may have to go into the restaurant business to create the product you want."

Nightlife on Beale, 1990.

I met with Preston Lamm to discuss the idea of going into the restaurant business. "Preston," I said, "We aren't going to make it unless we develop a concept that will give patrons the music and food that they are expecting to get on Beale Street. We need to develop several restaurants."

Preston replied, "John, you are losing a lot of money getting the property started. You could make this thing worse."

I replied, "Preston, I just can't wait. We need to get into the restaurant business. You've been in the club business before. I can get investors. If we don't do this, the whole street will fail. Beale Street is not special now. We know what to do; we just can't find anyone to do it. We need a blues restaurant that serves meals with meat and three vegetables."

Our group included Preston, Davis Tillman, Cynthia Ham and Kay McAdams, who was my secretary and had worked in the early days at Overton Square. Kay was terrific. She was smart and knew everyone who had learned the club business at Overton Square.

We spent weeks trying to figure out what we wanted the club to be like, what we would name the restaurant, who could manage it and, most important, how we could raise the money to open it. We finally worked up a true plan, which showed a modest profit. After two weeks, we had developed names, logos and concepts. We knew that we needed to have close to $300,000 to accomplish our goal.

Sid Haining, our contractor on Lenox School and Beachwalk Villas, was the person who came up with the name Rum Boogie Café. He had gone to Ole Miss and loved the blues. Davis Tillman drew up the logo, which was supposed to look like the most serious restaurant logo in the world at the time, the Hard Rock Café's "circle logo."

Kay McAdams found the management team, which consisted of people from Overton Square. The first manager was Sam Wolfe, who had worked at Friday's and Lafayette's Music Room on the square. One of his first hires was Bob Harding, who became a lifelong Beale Streeter and has worked on the street for over twenty-five years.

Preston and I flew to California to meet with our potential investment group because we knew no one in Memphis would put a dime into Beale Street. If it was difficult in 1982 and 1983 to get people to invest in Beale Street, it was impossible in 1984. We were to meet our investment group at the Ambassador Hotel, which is the same hotel where, in 1968, Bobby Kennedy was assassinated. Our meeting was for Monday, but Preston and I went out on Saturday so we could finalize our plan. The Ambassador was only a shell compared to what it once had been. We stayed in bungalows near the pool. The Ambassador was dated, but in its heyday, many of the great movie stars had stayed there. The second night, I convinced Preston to try to find out where Bobby Kennedy had been assassinated. We didn't find it. All day Sunday we sat at the cabana and finalized our plan. In fact, we were now beyond recommending the Rum Boogie; we were now recommending three other clubs: the Silver Fox, which would center on entertainer Charlie Rich; Lou's Place, which would feature Lou Rawls; and the Funky Chicken. We were also asking the investment group to fund two new real estate developments.

On Monday, the meeting went well, until we got to the restaurants. Needless to say, we were turned down on all but the Rum Boogie. Bill Bricker, the investment group's attorney, stood up and said, "I'll raise the money." And he did, from several of his clients, including Ivan Lendl, the tennis player.

We went home to start the club, which we hoped would help turn the street image around. One missing ingredient was our main entertainer. That year, we began building and buying apartments in Little Rock, Arkansas. One night in Little Rock, I went to a club called Club Memphis. I spent the night listening to a musician named Don McMinn. He had the right energy and charisma to make the place work. After three beers, and during the break of the second set, I walked up to him. "Don," I said, "my name is John Elkington. I'm redeveloping Beale Street and we're doing a Blues Club—"

Mr. McMinn interrupted and said, "Well it sure needs something."

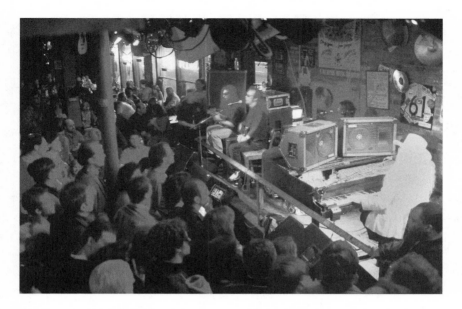

The Rum Boogie Café was instrumental in reestablishing Beale Street's reputation as the "Blues Capital of the World."

"We are looking for the right musicians to headline it. I'd love to have you," I said.

"I don't know," he said. "I'm looking for steady work."

"It will be steady," I said. I gave him my business card and told him we'd be calling him next week.

Years later, I asked him what he had thought when I first approached him. He said, "John, I thought you would never call." I did call, and for the next six years, Don McMinn built up the Rum Boogie and its reputation.

Initially, the club did great, but the manager, Sam Wolfe, left after several years. The next manager turned out to be a disaster, so in 1988 Preston got into it full time. It was his effort, foresight and determination that pulled the Rum Boogie through. I sold my interest to him a year later to help him secure additional investors, and the rest is history. The Rum Boogie became one of the greatest blues clubs in America, and Preston Lamm left his CPA firm forever.

BUD CHITTOM

The first time I recall meeting Bud Chittom was in early 1990 at an old house near Overton Square that served as his office. It apparently fit Bud's needs. My friend Rudi Schiffer was producing his magazine *Jackpot* at the house.

Bud had worked in the topless business and had built a number of very successful clubs. Bud had made it clear that Beale Street wasn't ready for him. He believed in the stability of Overton Square. But, surprisingly, two years after we first met, he made a decision to buy the Blues City Café from George Eldridge. Still grieving over the death of his only son, George Paul, a very handsome young man, George decided he had had all the fun he could handle in Memphis, and he sold the club to Bud.

Bud was a superb operator, but he had come from a background of noncooperation with other tenants. It was very hard at first for Bud to figure out that it was better to cooperate with his neighbors instead of retaliating. When he first got to Beale Street, Tommy Peters, the owner of B.B. King's Blues Club, which was across the street, hired one of his waitresses. That led Bud to one day walk across the street to B.B. King's. He walked in and said, "I'll give a $300 cash bonus to anyone that wants to leave right now." Almost the whole kitchen crew walked out on a Friday at prime time.

When the merchants decided to sell wristbands on Friday nights for ten dollars, Bud took on the challenge. He would sell more wristbands than any other tenant. He sold not only in front of his place, but all over the street, as well. Bud gave the street an edge that helped to improve its sales and increase its chance for success. Blues City Café thrived under his ownership.

SILKY SULLIVAN'S

In the early 1970s at his club in Overton Square, Silky Sullivan established himself as the premiere bar showman in Memphis. His

market was the growing population of Baby Boomers who were single, going to college or just entering the job market. They had disposable income, and the unique club that Silky established at Overton Square was right for them.

Silky had grown up off Highway 51 in Whitehaven, he had gone to Christian Brothers High School and then to Louisiana State University in Baton Rouge, Louisiana. The stories of his exploits at LSU are legendary. The idea of getting Silky to Beale Street in the 1980s seemed impossible. But, like others, he realized that in the early 1990s Beale Street was changing. The sons and daughters of those original Baby Boomers were now starting to go out, and they liked Beale Street.

In early 1991, he called me to start a dialogue about securing the old Gallina building on Beale Street. The building was in terrible condition and had no floor. The space next to it was simply a façade, and there was a bayou under it. The Gayoso Bayou, at the time, was an easement that you couldn't build over. He loved it. He visualized it as a Memphis version of Pat O'Brien's.

On hot summer days, he wore a white suit, smoked a cigar and held court outside his bar on Madison. He stopped every girl who came near the place and made them a "Silkette." He was simply the best person at striking up a conversation, making people laugh and making them feel at home. He also was a serious promoter. In fact, in the late 1980s, he organized National Football League preseason games in Europe. He promoted the Minnesota Vikings and the Chicago Bears in Norway on CBS-TV through Mike Lynn. Mike Lynn had tried to secure an NFL team for Memphis in the 1970s and had promoted preseason NFL games at the Liberty Bowl Stadium in Memphis. Mike later left Memphis and went on to become the president of the Minnesota Vikings.

Finally, in the summer, he called me to tell me that Babe Howard, a Millington, Tennessee entrepreneur, and J.D. Clinton, the son of bankers from Brownsville, Tennessee, and the president of Insouth Bank, wanted to go into business on Beale Street. They had been brought together by goats. Babe raised goats, among other things, and Silky had convinced him to put the money up for a club on

Beale Street. J.D. Clinton was reticent about the idea and certainly wasn't being swept up in the tide of excitement that Silky had created. "The Peabody Hotel has the ducks, we will have the goats," Silky said, puffing on his cigar.

We spent several months negotiating the lease, which included taking out our standard provision prohibiting live animals on the premises. One night, Silky came to my office to sign the lease with his fiancé, Babe and J.D. No one knew he had a fiancé. I asked, "Jo Ellen, when did you and Silky get engaged?"

"Oh, I don't know," she responded, "Ten years ago."

She turned out to be, for Silky and Beale Street, one of the best things that ever happened to us. She was as good an operator as Silky was a promoter. The addition of Silky and his manager, Jerry Buckley, added greatly to the growth of Beale Street in the 1990s. J.D. Clinton later became one of our bankers, but I remember running into him at Silky's after it had opened and when both of us were going through a divorce. "John," he said, "You and I need to hang around together since we are both in the same situation."

"I'd like that J.D." I said. "By the way, did you keep your house in Naples?"

"No, my wife got that," he responded.

"What about your condo in Buckhead?" I asked.

He answered, "No, she got that too. But, I did keep my home in Brownsville."

I jokingly said, "J.D., I don't need your number, I need hers!" He later remarried, and his investment on Beale Street, which he nervously watched over during the initial years, turned out to be a great investment. Silky and Jo Ellen turned out to be better than I could ever have imagined.

OTHER TENANTS WHO
MADE BEALE

The story of Beale Street includes the names of tenants who risked their reputations, wealth and careers to become a part of the redevelopment. Fran Scott was a securities dealer when he first became involved in Beale Street as an investor in B.B. King's. He did it because he loved music, and he wanted to give back to his community by bringing B.B. King back to Memphis. Later, he would invest in Crawdad's, which changed its name to Black Diamond. When we needed a "go-to guy," Fran always came through. He worked tirelessly to make the Beale Street Merchants Association Awards Banquet a worthwhile annual event, and his commitment to the street never wavered.

Mike Glenn turned the New Daisy into the first place on Beale Street that people wanted to access. I knew we were turning the corner when friends would call me about getting tickets to the New Daisy for themselves or for their children. Mike brought Bob Dylan, Prince, Hootie and the Blowfish, Elvis Costello, Wynton Marsalis, Keith Richards and Justin Timberlake, among others, to the stage of the New Daisy Theater. Whenever he was asked to help, he did. He fought a tough music market more than once, but he made the New Daisy a great venue.

It would not be Beale Street without the Historic Daisy Theater.

James Clark never wavered from his commitment to his decision to locate on Beale Street. He was the only retail owner who made it for over twenty years in a retail-hostile area.

OUR STAFF

The lessons I learned on Beale Street have helped me as I developed other urban entertainment areas. Security is still the number one issue everywhere. To be special, we still need unique food and music. Everyone knows more than you do. There will always be people who want to criticize you or who think they know better. Have the confidence to complete the task. Make sure every partner is empowered and that your public partner is committed. Do we know more today than we knew when we started? The answer is yes. You can't do a development without a lot of people who have talent and have the same commitment to get it finished as you do. We had that on Beale Street.

Al James spent more time on the redeveloped Beale Street than any other person. Every morning for more than twenty-five years, he got up before 5:00 a.m. to get to Beale Street by 6:00 a.m. He made sure the garbage was picked up, the broken parts were fixed and the street was clean. He was there when it rained, snowed or was over one hundred degrees and dry as the desert. He was there when Hurricane Elvis came through and caused a crane that was being used in construction at the FedEx Forum to bend and lean at a forty-five-degree angle over Beale Street. It threatened to destroy several of the historical buildings.

Opening of the New Daisy Theater.

"Whatever you want to do." Al said those words every day we worked together. He believed in the dream and was the person who, more than anyone else, made it happen. His favorite expression was, "This job is not for everybody." Through early 2002, he closed the street every night. He was there for all the Liberty Bowl parades that our company started producing in 1993. The most interesting parade occurred in 2000. The parade was being televised on Fox 13. It started on Second Street, near downtown's Court Square, and was led by a police motorcade. Suddenly, it stopped near an alley across from the Peabody Hotel. Al, who couldn't see what was causing the parade to stack up, was asking what was wrong. He received a response that the police had found a body. Al responded, "If it's on Beale, move it off!" Fortunately, it wasn't.

He was there for three Olympic Torch Runs down Beale Street, and he was there for Hands Across America, which was a 1985 attempt to have people line up hand-in-hand across the United States. He went through every crisis and every negative newspaper

story, but he was there for the good things, too. He was there for the openings of each restaurant or retail business, the televised New Year's Eve broadcasts, the rebuilding of the street and the redevelopment of Handy Park. He made sure that homeless people were fed, and he made sure that they had a warm place to sleep on cold nights. Through it all, he kept an even temper and kept Beale Street running.

There were others: Cynthia Ham, Davis Tillman, Toni Holman-Turner, Sherry Misner, Shannon Black and Darren Fant, all of whom, over twenty-five years, shaped a marketing plan that took Beale Street from a marginal entertainment center to one of the most visited attractions in Tennessee. Cynthia and Davis developed music events that first introduced the community to the music and culture we outlined in our original business plan. Throughout the years, the Beale Street Historic District was blessed by marketing people who shaped the image from an unsafe, unstable, uninviting area to one of the largest attractions in Tennessee.

The idea advanced by many that Beale Street had such a great historical name should have made it easy to redevelop. It wasn't.

Grand opening party on Beale.

By 1983, the street had been physically empty and deteriorating for ten years. Its high point had been in the 1920s and 1930s. The decline began in the 1950s and was accelerated in the 1960s. A whole generation of Memphians had never experienced Beale Street. In the 1970s, Memphis was becoming more suburban and was moving away from its downtown base. Our marketing group had to change this.

In 2002, Mike Matthews, an investigative reporter for WREG-TV, stood on the corner of Beale and Second and called Beale Street the safest place in Memphis. That statement was accomplished by the emphasis on security for nearly twenty years.

The marketing group did other things to move Beale Street forward: 1) eliminated outdoor bars on Beale Street (though they had been a hard-fought concession won in the state legislature, they proved to be messy and created an image we didn't want as we reached maturity); 2) helped create a music scene that developed our own Beale Street stars like Ruby Wilson, Preston Shannon, Don McMinn and James Govan, who were critical in giving Beale Street an identity; and 3) developed the Zydeco Music Festival in February, Spring MusicFest, Labor Day Music Festival and the New Year's Eve Countdown on Beale, all of which were created by Cynthia Ham and Davis Tillman.

Later, in 2001, the Country on Beale Music Festival, in cooperation with Kix-106, brought a new entertainment element to Beale Street: country music. The use of wristbands for events was created by Cynthia Ham, and the festival gave starving Beale Street tenants their first big paydays in September 1984. At first, all we cared about was getting crowds. Later, we learned that crowds are a double-edged sword—big crowds that are just loitering and not spending money don't help. However, there was one exception in which we wanted a big crowd—our New Year's Eve televised "Countdown on Beale" event. The Countdown on Beale broadcast centered on constantly showing the size of the crowd, which was always huge. It was important to show the Memphis television audience that Beale Street was back.

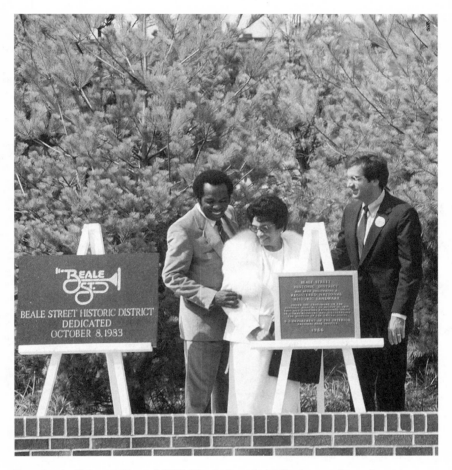

Irma Louise Logan, widow of W.C. Handy, is on hand for the grand opening.

We originated the Liberty Bowl parade on Beale Street and built it into a key part of the Liberty Bowl Festival. The Christmas parade was moved to Beale, and through the 2000s and later all other parades in downtown started or finished on Beale. Toni Holman-Turner and Al James worked feverishly every year on the Liberty Bowl parade, taking us from 16 pieces the first year to over 120 pieces in the parade in 2004. The redevelopment of Handy Park was a major change in our marketing strategy against the strong objections of the Memphis Park Commission board and staff and

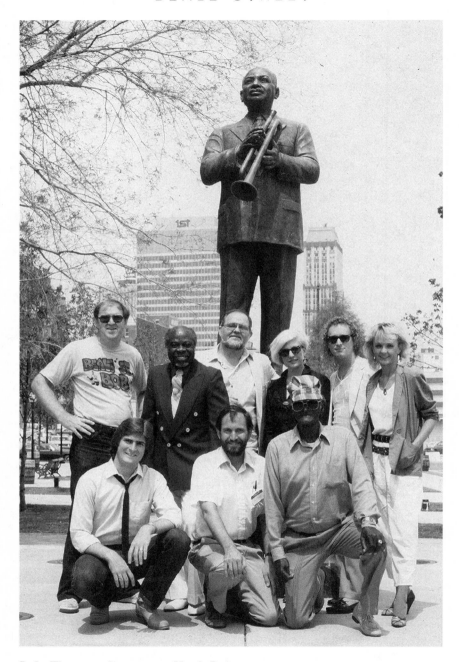

Rufus Thomas and company at Handy Park.

our neighbors, the Belz Company, who were concerned about what we were creating next to their prize development, Peabody Place.

Despite the initial losses, we thought it was worth it. We created a positive venue that had fifteen to eighteen musical events a year. It also provided a place for street musicians who excited visitors on Beale Street daily. All of these things were created by a staff that believed in the dream and made Beale Street work.

Finally, we are fortunate to have had people like Joe Sabatini, Mike Ritz, Robert Boyd, Paul Gurley and Joe Calabretta, who ran the day-to-day business of Beale Street, enforced the rules and supervised our staff members. Dianne Glasper, Vickie Redd and Cookie Johnson all played a part in communicating to the public what we were doing, listening to the complaints and being the first line of communication for our company.

Our staff was never fully compensated for what they did. Through their efforts, these people, along with our merchants, created what the *Memphis Business Journal* called "one of the greatest commercial real estate turnarounds in the history of the United States."

LESSONS LEARNED

LESSON NUMBER ONE

When you add a nonprofit to a development equation, make sure you know what its mission or role is, whether it can carry that mission out and what missing ingredient it can add to the development process.

LESSON NUMBER TWO

During our twenty-five years on Beale Street, there were many problems, events and even crises that occurred or were averted. Joe Sabatini told me after one such event to always remember that "this, too, shall pass."

In retrospect, he was correct. Usually, the most difficult times are when the press gets involved in a problem or incident that questions your competency, ability, honesty or judgment. Sometimes the crisis is caused by a tenant, third party, contractor or customer. You need to be able to handle these events without losing perspective.

It was my experience that the media always wants to appear balanced, so they always try to find someone who will give an opposing opinion. In a public/private partnership, it doesn't seem to matter whether the person interviewed is incompetent or even knowledgeable about the situation—the media just need someone to comment on you or the issue. The worst interviewees are those who are convinced that they can do a better job than you, even though they lack the necessary skills to develop a property, manage or lease it.

There are countless others who will pass judgment on your development skills. Hershel Lipow, who once headed Housing and Community Development (HCD) for the City of Memphis, is a perfect example of this. He lasted one year at HCD. He was a bright guy who had no common sense. He was hired to give the Hackett administration an in-house "liberal." He was once quoted in the *Commercial Appeal* as saying "Beale Street needs to be more like Colonial Williamsburg." What was he thinking?

LESSON NUMBER THREE

If you are burned once by an individual or an organization, don't do business with them again unless there is a material change in their personal, structural or operating method.

My first question to someone with whom we did unsatisfying business before is, "What is different from the first time we did business?" I learned that painful lesson several times on Beale Street.

In a development of this magnitude, in a city the size of Memphis, you have to attract numerous groups of people: leisure, group and recreational tourists; conventioneers; business travelers; and, more importantly, people who live in the community. Without layering these groups, you can't be successful in supporting the critical mass of business necessary to make the development succeed.

LESSON NUMBER FOUR

If you are going to be in the development business, especially a public/private partnership, you are subject to the criticism of everyone. If you can't take criticism, scrutiny or comments, get out. You are open prey to everyone. Today, it is worse, with the bloggers, talk show callers and others who can issue uninformed and biased opinions and hide behind the curtain of anonymity. They treat their opinions as facts, make up stories, tell half-truths or simply lie. They may try to extort money or advertising dollars from you to stop. Keep an even temperament. Don't get too high when things are good and don't get too low when things are going wrong.

LESSON NUMBER FIVE

Make sure that all leases require a tenant to invest money into their premises. They need to have some sort of liability to prevent them from quitting when things get rough. Don't allow them to walk away if occupancy falls below a certain level or if their sales don't hit a target. They need to have the same commitment you have.

LESSON NUMBER SIX

In a public/private partnership, don't overstay your involvement. Twenty-five years is a long time. People forget what the property was like, what the obstacles were and the struggles. Be sure to structure a deal that has an exit strategy.

LESSON NUMBER SEVEN

In public/private partnerships, make sure everyone has a role and is empowered. Make sure the government entity has certain

things that it must do to keep it involved and organized throughout. Everyone has a tendency to show up for the grand opening, but they are hard to find when things get tough. Require monthly meetings and an agenda. Politicians love to play the "blame game." Make sure they know it is a two-way street when things don't go as planned.

LESSON NUMBER EIGHT

Have a financial plan that provides significant investment capital. Use your funds as a reserve. This does two things: it gives you a second pair of eyes in examining your development, and it provides precious capital, which is hard to find if things don't work out as you planned. Don't be undercapitalized—it puts a strain on you and your people.

LESSON NUMBER NINE

Don't do easy things. Do things that challenge you; things that make a difference in a community; things that are special and that contribute to the betterment of a community.

LESSON NUMBER TEN

Develop a vision, create a plan to carry out the vision and hire people who believe in that vision.

LESSON NUMBER ELEVEN

Mentors are very important. Seek out people who are willing to give you advice, help you solve problems and will give you a different perspective on an issue. I was blessed to have the opinions

of a lot of great businesspeople, like Avron Fogelman, Jack Belz, Dean Jernigan, Frank Rosenberg, Carol Coletta, Ron Terry and Ron Willard.

LESSON NUMBER TWELVE

It doesn't matter who gets the credit as long as the job gets done. Just make sure it gets completed. As my dear friend Avron Fogelman told me repeatedly in life, "Don't confuse effort with results."

LESSON NUMBER THIRTEEN

Remember, in order for an urban entertainment-retail development to succeed, it needs to be unique and different—a special place that should include the music, history and culture of the community. Applebee's, Chili's and Macaroni Grill are fine, but they are not going to make a development unique and special. The independent restaurant and club owner will. This makes it harder to finance, but you can end up with a more unique product. The uniqueness makes it special and brings people from the suburbs—not sameness. We are too guilty in America of homogenizing our commercial developments.

LESSON NUMBER FOURTEEN

Race in the South has been the central issue in the lives of its people. We can never get away from it. During my Leadership Memphis training, participants conducted an exercise using a hypothetical situation in which a person's car breaks down late at night on a deserted road. There is a white family on one side of the road and a black family on the other. During the exercise, the black participants and white participants were asked to which house they would go.

In my life, I have reached out to many black businessmen, lawyers, ministers and leaders, such as Robert Spence, Harry Miller, A.W. Willis, Reverend Kenneth Whalum Jr., Cato T. Walker III, Reverend Bill Atkins, Johnny Moore, Dr. W.W. Herenton, Clift Dates, Steve Sallion, Calvin Taylor and Percy Harvey.

Until people reach out to one another, we aren't going anywhere as a community. As long as the eleven o'clock Sunday morning service is the most segregated hour of the week, we are not going anywhere. As long as we allow people of whatever color to divide us, we are not going anywhere.

LESSON NUMBER FIFTEEN

The thing you must always remember in real estate is that longevity can pull you out of a bad real estate deal. If you can hold on long enough, the economics will eventually help you, if they were based on a good plan.

BEALE STREET BUSINESSES

Alfred's On Beale
197 Beale St. at Third
Memphis, TN 38103

Alley Cats
156 Beale Street
Memphis, TN 38103

A. Schawb
163 Beale St
Memphis, TN 38103

B.B. Kings Blues Club
143 Beale Street
Memphis, TN 38103
bbkingbluesclub.com/Memphis/index.html

Beale St. Tap Room
163 Beale Street
Memphis, TN 38103

The Black Diamond
153 Beale St
Memphis TN 38103

Blues City Café & Band Box
138 Beale Street
Memphis, TN 38103

Club 152
152 Beale St.
Memphis, TN 38103

Double Deuce
340 Beale Street
Memphis, TN 38103
www.doubledeucememphis.com

Dyer's Famous Hamburgers
205 Beale St.
Memphis, TN 38103
www.dyersonbeale.com

Eel Etc. Fashions
333 Beale Street
Memphis, TN 38103

Hard Rock Cape
315 Beale Street
Memphis, TN 38103
www.hardrock.com

King's Palace Café
162 Beale Street
Memphis, TN 38106
www.kingspalacecafe.com

Memphis Music
149 Beale Street
Memphis, TN 38103

Mr. Handy's Blues Hall
182 Beale Street
Memphis, TN 38103

New Daisy Theater
330 Beale Street
Memphis, TN 38103
www.newdaisy.com

New York Pizza
341 Beale Street
Memphis, TN 38103

Pat O'Briens
310 Beale Street
Memphis, TN 38103
www.patobriens.com/memphis.html

People's Billiard Club
323 Beale Street
Memphis, TN 38103

The Pig on Beale
167 Beale Street
Memphis, TN 38103
www.pigonbeale.com

Psychics of Beale Street
154 Beale Street
Memphis, TN 38103

Rum Boogie Café
182 Beale Street
Memphis, TN 38103
www.rumboogie.com

Silky O'Sullivan's
183 Beale Street
Memphis, TN 38103
www.silkyosullivans.com

Strange Cargo
172 Beale Street
Memphis, TN 38103

Tater Red's
153 Beale Street
Memphis, TN 38103

Wet Willies
209 Beale Street
Memphis, TN 38103

NOTES

BEALE STREET'S HISTORY

1. Richard M. Raichelson, *Beale Street Talks: A Walking Tour Down the Home of the Blues* (Charleston, SC: Arcadia Publishing, 1999).
2. William S. Worley, *Beale Street, Crossroads of America's Music* (Lenaxa, KS: Addax Pub. Group, 1998).
3. Ibid.
4. Robert Sigafoos, *Cotton Row to Beale Street* (Memphis, TN: Memphis State University Press, 1979).
5. Roberta Church, "Facts about Beale Street 1849–1870 and the Occupation of Women 1855–1870" (unpublished manuscript, March 1994), 1.
6. Beverly G. Bond and Jannan Sherman, *Memphis in Black and White* (Charleston, SC: Arcadia Publishing, 2003), 49–51, 54, 58.
7. Carol Van West, *Tennessee Encyclopedia of History and Culture* (Nashville: Tennessee Historical Society, 2002).
8. Raichelson, *Beale Street Talks*.
9. Van West, *Tennessee Encyclopedia*.
10. Ibid.
11. Ibid.
12. Ibid.

13. Ibid.

14. Geoffrey C. Ward and Ken Burns, *Jazz: A History of America's Music* (New York: Alfred A. Knopf, 2000), 15.

15. Ibid.

16. Ibid., 84.

17. Harland Bartholomew & Associates, Inc., "Market Study for Beale Street Historic District," March 26, 1982, 3.

18. Ibid.

19. Ibid.

20. Ibid.

HOW WE GOT INVOLVED

21. Joshua Olsen, *Better Places Better Lives, A Biography of James Rouse* (Washington: Urban Land Institute, 2003), 290.

22. "Memphis Mud, Music, a Miracle," *Houston Chronicle*, July 24, 1983.

23. Ibid.

24. Ibid.

25. "Developer Spotlights Beale's Unique Qualities," *Memphis Press Scimitar*, January 27, 1982.

26. Ibid.

27. "Co-Developers of Beale Cite Problem Areas," *Commercial Appeal*, January 30, 1982.

28. "Celebrating the City," *Builder Magazine* (February 1984): 96.

29. "Memphis Mud, Music, A Miracle."

ABOUT THE AUTHOR

John A. Elkington is the president and CEO of Performa Entertainment Real Estate, Inc., one of the top companies in the urban redevelopment field. He has served on the board of the National Civil Rights Museum, the National Slavery Museum and the Center City Development Corporation. He also served as the chairman of the Memphis and Shelby Land Use Control Board. His many awards and accolades include the Blue Note Award from the National Blues Foundation for support of the blues music community and the A.W. Willis Preservation Award from the Memphis Heritage Foundation in 1999. He is a graduate of Vanderbilt University and the University of Memphis Law School.

Visit us at
www.historypress.net